IMAGES
of America

SWEDES IN OREGON

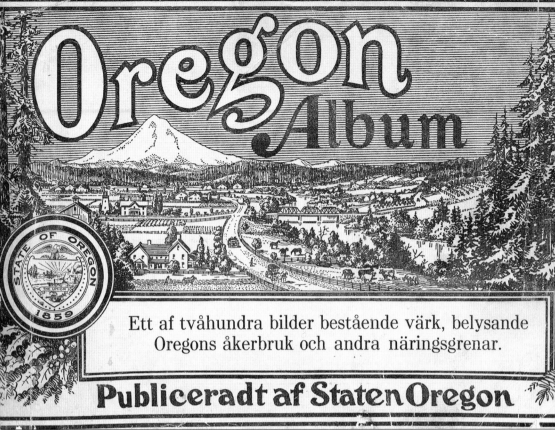

Oregon Album

STATE OF OREGON · THE UNION · 1859

Ett af tvåhundra bilder bestående värk, belysande
Oregons åkerbruk och andra näringsgrenar.

Publiceradt af Staten Oregon

In the fall of 1914, the Oregon State Immigration Commission published the *Oregon Album*. It was distributed to immigrants, settlers, and investors who sought information about Oregon. The publication included over 200 photographs of agriculture-related industries. Many of the featured farms were owned and operated by Swedes. The captions were written in both Swedish and Norwegian. (Courtesy of Ross Fogelquist.)

ON THE COVER: Linnea Hall, completed in 1910 by the oldest Swedish organization in Portland, the Swedish Society Linnea (*Svenska Sällskapet Linnea*), was a social center for many activities in the Swedish community. In this photograph taken on Christmas in 1945, folk dancers performed, led by Ed Okerström. The dancer on the right, Bob Anderson, was the host of the popular Sunday morning radio program *The Scandinavian Hour* for many years. (Courtesy of Ross Fogelquist.)

IMAGES
of America

SWEDES IN OREGON

David A. Anderson and Ann Baudin Stuller
on behalf of the Board of Directors
of Swedish Roots in Oregon
Foreword by Rhonda Erlandson

ARCADIA
PUBLISHING

Published by Arcadia Publishing
Charleston, South Carolina

Printed in the United States of America

Library of Congress Control Number: 2020939159

For all general information, please contact Arcadia Publishing:
Telephone 843-853-2070
Fax 843-853-0044
E-mail sales@arcadiapublishing.com
For customer service and orders:
Toll-Free 1-888-313-2665

Visit us on the Internet at www.arcadiapublishing.com

To the parents and grandparents of Oregonians with Swedish roots

CONTENTS

FOREWORD

As the daughter and granddaughter of Swedish immigrants, my childhood was steeped in Nordic traditions. At Christmas time, my grandparents hosted a lively *julafton* with *lutfisk, sill,* a variety of cookies baked from Swedish recipes, and presents spirited in by *jultomte* and his *julbok.* The evening seemed to transport me to a distant snowy land, illumined by the Aurora Borealis. Later, bundled up and off to candlelight services in the pioneer Lutheran church in Warren, Oregon, we softly greeted Christmas morning with hymns in the old language.

Six months later, *midsommar* arrived. A bounty of food packed in baskets made by St. Helens, Oregon, Swedish basket-maker John Peterson accompanied us to the annual "Swedish picnic." I proudly wore the costume my grandmother made for me as I skipped and played around the *majstång.* At twilight, we headed to a pavilion where my grandparents danced the *hambo, schottische,* waltz, and polka.

These experiences inspired my lifelong passion for preserving Swedish heritage, particularly in Oregon, where so many Swedes settled. By 1930, one in every ten foreign-born persons in Oregon was a Swede. This concentration of Swedish immigrants influenced Oregon's development of ports and bridges, hospitals and libraries, and businesses, as well as the state's approach to labor issues and fishing, logging, farming, and legislative priorities.

In 2019, Swedish Roots in Oregon (SRIO), a nonprofit organization dedicated to researching the history of Swedish immigrants in Oregon, presented a major exhibit titled *From Sweden to Oregon: The Immigrant Experience 1850–1950.* Funded by grants from the Swedish Council of America, the Cultural Coalition of Washington County with funds from the Oregon Cultural Trust, and generous gifts from local Swedish organizations and individuals, the exhibit ran for three months at Nordia House, home to Nordic Northwest, Oregon's premier Scandinavian cultural heritage organization.

Now, in *Swedes of Oregon,* David Anderson and Ann Baudin Stuller provide additional material that builds on the themes presented in SRIO's exhibit. With captivating images and research, it opens a vivid window into the lives of our Swedish ancestors, revealing their hopes, dreams, accomplishments, and the remarkable impression they made on Oregon's culture, economy, and ongoing legacy. *Varsågod!*

Rhonda Erlandson
Former president, Swedish Roots in Oregon
March 2020

ACKNOWLEDGMENTS

The authors would like to express our gratitude to the many people who helped make this book a possibility: Steve Greif and Debra Semrau of the Coos History Museum, Elerina Aldamar of the Oregon Historical Society, Christine Nyberg Tunstall and the John Nyberg family, members of Swedish Society Linnea, Tom Swanson, Suzanne Nelson, Ruth Summers, Laura Rendahl, Diane L. Glase, Janet Lundell Ahlin, Ryan Fernandez of the *Oregonian*, Ross Fogelquist, Sue Brooks Ceglie, Charline Gebhardt, Julia Barbee Suplee, Alf-Erik Thelin, Unnie Malmén, Rhonda Erlandson, Vanessa Ivey of the Deschutes County Historical Society and Museum, Howard and Della Larson, Sachiye and John Jones, Les Watters of the Columbia County Museum Association, and Meg Langford and Steve Duckworth of the Oregon Health Sciences University Library. Our deepest gratitude to Debra Semrau of the Coos History Museum for filling a request for photographs just before being furloughed due to the COVID-19 pandemic. To Sid Stuller and Andrew Stern, our thanks and appreciation for humoring the authors in our endeavor in authoring this book. To Christine Nyberg Tunstall, Diane Glase, Hans Sohlstrom, and Svenska Sällskapet Linnea, a very special thank-you for your generosity in supporting our small group. *Tusen tack* to all.

Tusen tack to our editor Caitrin Cunningham for her guidance and help and to the entire staff of Arcadia Publishing for helping us tell the story of our Swedish ancestors in Oregon.

We hope for the best for all the museums, historical societies, and everyone in these trying historic times. To everyone who loves history, please keep taking photographs and recording the present, because the present will become the past, and people will someday look at those photographs and wonder what it was like back then.

We sincerely apologize for any errors or inaccuracies. We have done our utmost to verify the accuracy of our information and sources.

INTRODUCTION

The earliest Swedes in the Pacific Northwest were trappers and traders in the service of Hudson's Bay Company or the Russian American Company. According to the US Census of 1860, approximately 90 Swedes were living in Oregon and the Washington Territory. They had come from the California Gold Rush or over the Oregon Trail or were sailors who jumped ship in ports along the coast. Most were attracted to the area due to the farming, fishing, and logging opportunities—activities familiar to them at home in Sweden. Toward the end of the 1880s, more and more of the immigrating Swedes were skilled craftsmen, engineers, builders, and businessmen. Often, their children eventually pursued academic and public service careers. The Swedes who came to Oregon arrived relatively late in the settling of the state, as evidenced by geographical place names; those that remain may be found in Clatsop County (Karlson Island, Svensen), along with a few others along Oregon's coast and in southern Oregon. Instead, evidence of Swedish settlements can be found in the naming of roads: Swedetown Road in Clatskanie, Palmquist Road in Powell Valley, and Hult Road in Colton.

The migration of Swedes to Oregon came alive in the 1880s and culminated by 1930, after the beginning of the Great Depression. The first increase was largely due to the completion of a transcontinental railway line to Portland in 1883 and the availability of land in rural areas for homesteaders. Many who first immigrated and settled in the Midwest eventually continued on to Oregon. The development of irrigation projects also opened new lands for settlement, and modern exploitation of the vast timber resources offered business opportunities.

In addition to being mentioned in letters and via word of mouth, Oregon was featured in advertisements and publications directed toward newcomers from Sweden. The Oregon Immigration Department issued the *Oregon Album* in Swedish (and Norwegian), appealing visually to prospective citizens and investors. Ernst Skarstedt, in his trilogy about the Pacific Northwest, wrote in Swedish and photographed Oregon's features and Swedes living in the state. In Sweden, publications such as *Amerika-Boken* described the state's physical features and existing job opportunities. *Oregon Posten* (*The Oregon Post*), a Swedish language newspaper published in Portland with a subscription base in Oregon and elsewhere in the United States and Sweden, reported each week on the developments of the Swedish American community in the state.

The Swedish-born population in Oregon centered around the Portland area. One of the first significant Swedish agricultural settlements was in Powell Valley, east of Portland. This fine farming area still supplies excellent produce and berries. Warren, located 20 miles northwest of Portland near the Columbia River, was the center of another agricultural region settled by Swedes and Swedish-speaking Finns. Along the lower Columbia River, all the way to Astoria and along the Oregon coast, Swedish immigrants supported themselves by farming, logging, and fishing. Wheat-growing in north-central Oregon also attracted Swedes who began arriving in the later 1800s near Ione in Morrow County. The forest industry teemed with Swedes, and they established sawmills in Coos County and elsewhere.

By 1930, more than 11,000 Swedes had made Oregon their home state, and about 45 percent of them were living in Portland. They could often be found working in the building and woodworking industries and as engineers, designing bridges and other structures needed to support a continuously growing citizenry. Swedes were everywhere in public life—from a newspaper music critic to governor of the state. They had drug, shoe, hardware, cigar, book, and grocery stores; they ran hotels, bakeries, restaurants, printing shops, travel agencies, lumber yards, and saloons; and they were photographers, blacksmiths, butchers, police officers, undertakers, teachers, doctors, dentists, physical therapists, publishers, pastors, bankers, real estate brokers, tailors, seamstresses, domestic workers, nurses, labor leaders, and insurance agents.

Apart from establishing churches and hospitals, these immigrants promoted Swedish culture and traditions, along with a concern for welfare, through various social organizations. The Swedish language originally served as a unifying force for such groups and continued to be used for meetings and various functions such as choral performances. Some of these organizations remain in existence and are still active today. Others have dwindled as members have moved or died. New ones have arrived on the scene, but it is their common Swedish heritage or interest that unifies them. Swedish cultural activities in Oregon—such as Scanfest in Portland, Midsummer in Portland and Astoria, and the Scandinavian Festival in Junction City—now include other Nordic nationalities.

Although the major waves of immigration to the United States from Sweden occurred before 1900 and found many Swedes settling in the Midwest, some immigrants eventually found their way to the Pacific Northwest. They relocated to an area very geographically and physically similar to their homeland. Oregon gave them an abundance of land and a milder climate, which helped them to overcome the hardships, distance, and new language. The bulk of Swedish immigrants who settled elsewhere in the United States came from the agriculturally poor area of Småland in southern Sweden. Although all of Sweden's provinces were represented in the Oregon immigrant population, the largest group came from Värmland in central Sweden.

With the internet, Swedish newspapers can be read when they are published, and Swedish television and movies are easily accessible. Contact through email and social media has broken the distance barrier: there is no longer a wait of six weeks or more to receive news from family and friends in Sweden. The tools of genealogical research can assist with reconnecting families who were separated many years ago. Apart from the traditions of the past, there is a consciousness of modern Sweden when a Volvo or Saab passes by, when one makes a purchase at IKEA, or when a salmon is caught using an Abu fishing reel. These, and other products used daily, are reminders of the close economic ties between the United States and Sweden.

Not all Swedes adjusted to their new home in Oregon. Some returned to Sweden when the Great Depression settled over the United States. Others found family ties and obligations too strong and returned home—some with successes, others with failures. However, what remains for the descendants of those Swedish Oregonian immigrants is a heritage of the past tempered with modern society in which the old world is all the closer in distance and time.

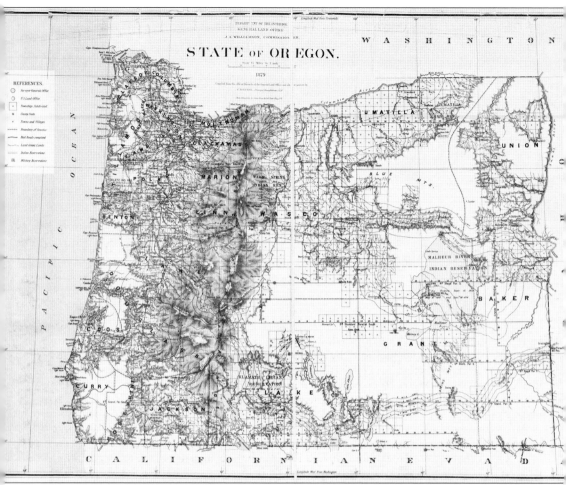

This map of Oregon dates from 1879 and was issued by the US Department of the Interior's General Land Office. It was compiled from official records of the General Land Office by C. Rouser, principal draftsman. It shows the counties that had been named at that time, military roads, and Indian reservations later taken away by the federal government from the original inhabitants of the region. There was land that had yet to be officially surveyed. The map represented a time of great transition. This was a time when white women had few rights, and Native Americans had none. It was a time just after the last of the Indian Wars in Oregon and the subjugation of its indigenous population. This was a time when the iron horse (railroad) was being expanded across the continent, and half of the land was given to railroad companies to cut trees used for fueling the steam engines that transported new settlers. (Courtesy of the New York Public Library Digital Collections.)

One

THE GREAT MIGRATION

From 1850 to 1930, about 1.2 million Swedish-born men, women, and children immigrated to North America. There were myriad reasons why the Swedes left their homeland besides economic ones. The advertisements of steamship lines enticed those filled with a spirit of adventure. Religious freedom attracted others, and for young men, it gave them a way to escape military service. Most of the immigrants remained in North America; however, about 400,000 would eventually return to Sweden.

Although two Swedes were present in the Oregon Territory and counted in the 1850 census, the migration of Swedes to the Pacific Northwest did not begin in earnest until the 1880s. The influx of Swedes continued to rise until around 1930. With the completion of the transcontinental railroad in 1869, Washington, Oregon, and California became destinations for thousands of Swedish immigrants. Their journeys can be traced through census records, Swedish immigration records, and ships' lists, as well as other documentation.

Portland was linked to the national railroad network when Northern Pacific completed the nation's third transcontinental route by using the line of the Oregon Railway and Navigation Company. The first transcontinental train arrived in Portland on September 11, 1883.

The Swedes were among the largest immigrant groups in Oregon. During the period from 1850 to 1940, only Canada and Germany sent more immigrants to Oregon. A considerable number of additional immigrants to Oregon were Swedish-speaking Finns or Swedes born in Finland. When these Finns were added to the Swedish totals, the number of Swedish speakers came closer to the number of people from Germany. Emigration was well scattered from Lapland in the north to Malmö on the southern tip of Sweden. Skåne, Västergötland, Småland, Östergötland, and Värmland were areas contributing the largest portions of immigrants who came to the United States. The final peak immigration period was around 1923. The 1929 Wall Street crash and the Depression years of the 1930s provided little incentive for emigrants to leave Sweden, where, eventually, the economic and social conditions improved to such an extent that Sweden became an immigration destination.

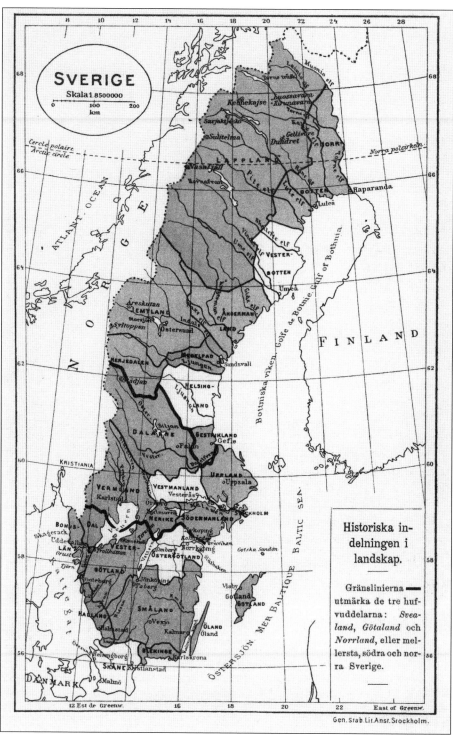

Most immigrants to North America originated from the more populated areas of central and southern Sweden: Skåne, Västergötland, Småland, Östergötland, and Värmland, as shown on this 1901 map of the old Swedish provinces (*landskap*). (Courtesy of runeberg.org.)

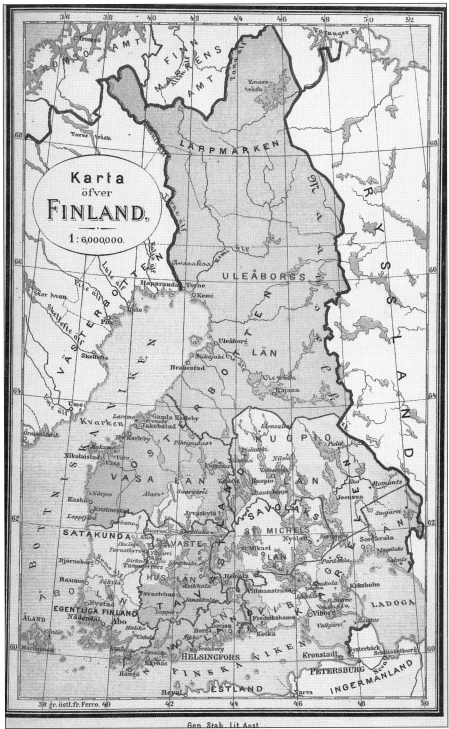

Swedish-speaking areas of Finland include the island of Åland and the coastal regions of Österbotten, Åboland (Egentliga Finland), and Nyland. This map is from volume 1 of *Finland i Nordiska Museet* by Artur Hazelius, published in 1881. (Courtesy of the British Library.)

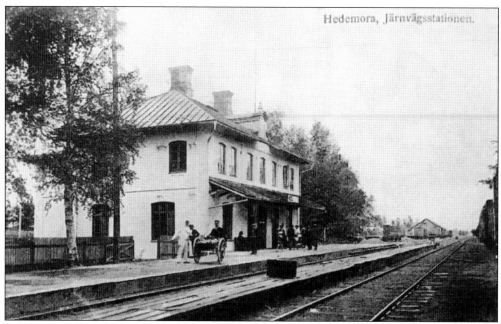

The journey to North America often began at the local railroad station. From there, the destination was usually Göteborg, where boats transported passengers to one of England's east coast ports, such as Hull. (Courtesy of David Anderson.)

Afskedet

Tack, fädernesland, för allt nyttigt jag lärt,
för allt hvad jag håller så innerligt kärt!
Visst mycket däraf med på färden jag tar;
men hjärtat det stannar i hembygden kvar.

Förlag F. Gustavson, Göteborg

Göteborg den 23/6 1905

Matilda

Once travelers arrived in England, they took a third-class train ride across the country to an Atlantic port, typically Liverpool, where the emigrants from Sweden boarded transatlantic ships bound for various ports of North America. An old Swedish proverb illustrates the feelings of the departing Swedes: "*För att korsa havet, måste du ha modet att lämna land*" ("In order to cross the sea, one must have the courage to leave land"). (Courtesy of David Anderson.)

Utfl.-n:r *159*

Flyttningsbetyg till utlandet.

1. från _____ *Nederkalix* _____ församling i _____ *Norrbottens* _____ län,

2. postadress _____ *Kalix*

3. till _____ *Nordamerikas Förenta Stater*

4. utfärdat den *5 september* _____ år 192*3* för följande *1 m.* kv.

5. _____ *Jordbruksarbetaren*

6. _____ *Fredrik Gotthard Baudin*

7. är född den *11 februari* _____ år *1900* (*nittonhundra* _____)

8. i _____ *Nederkalix* församling i _____ *Norrbottens* _____ län,

9. är _____ vaccinerad, är _____ döpt

10. har inom svenska kyrkan konfirmerats med _____ *godkänd* _____ kristendomskunskap,

11. har inom svenska kyrkan begått H. Nattvard,

12. _____

13. är ogift

14. _____

15. såsom värnpliktig *159 74/1920; erhållit vederbörligt tillstånd att emigrera;*

Permission to emigrate from Sweden was obtained from the local pastor's office. The required document contained the following information: residence, destination, occupation, birthdate, whether one was vaccinated, whether one had been baptized and confirmed, marital status, and military service status. The document was valid for a month, and if it was not used, it had to be returned to the church. (Courtesy of Ann Baudin Stuller.)

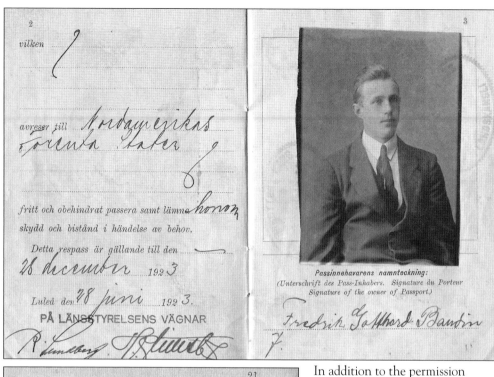

Passinnehavarens namnteckning:
(Unterschrift des Pass-Inhabers. Signature du Porteur
Signature of the owner of Passport.)

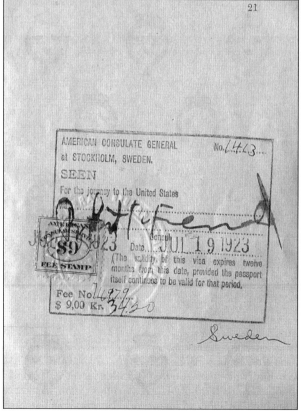

In addition to the permission document, a passport was needed to enter the United States. This was issued by the county or *län* and was valid for six months. The passport contained a physical description of the individual along with a photograph and signature. (Courtesy of Ann Baudin Stuller.)

The passport had to be submitted to the American Consulate in Stockholm, where a visa permit was stamped to grant one permission to travel to the United States. In 1923, the fee was $9, or 34.20 Swedish *kronor*. The visa was valid for up to 12 months or as long as the passport was valid during the same period of time. (Courtesy of Ann Baudin Stuller.)

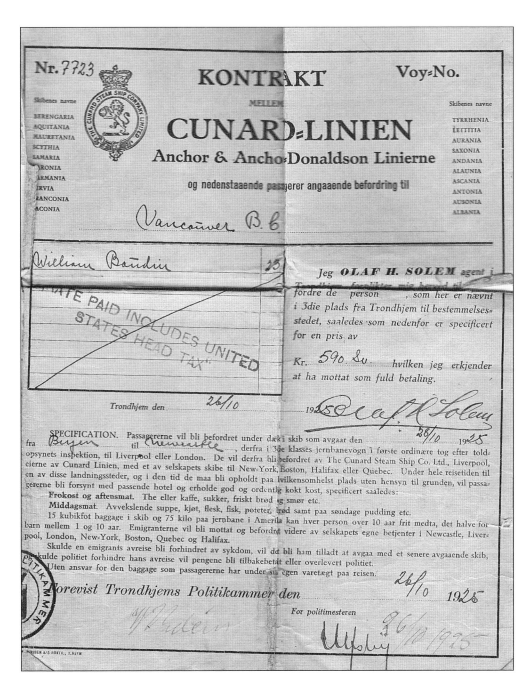

This ticket for departure from Trondheim, Norway, was for William Baudin from Korpikå, Kalix, Norrbotten, Sweden. The route included in the ticket was: Bergen, Norway; Newcastle and Liverpool, England; Quebec City, then across Canada by train to Vancouver, British Columbia. The ticket was stamped and signed by the Trondheim police on October 26, 1925. The price of the ticket was 590 Swedish *kronor* (about $160). The transatlantic ship was the *Aurania*, and the final destination was Portland, Oregon. It was more convenient for people living in northern Sweden to depart from Trondheim rather than Göteborg. (Courtesy of Ann Baudin Stuller.)

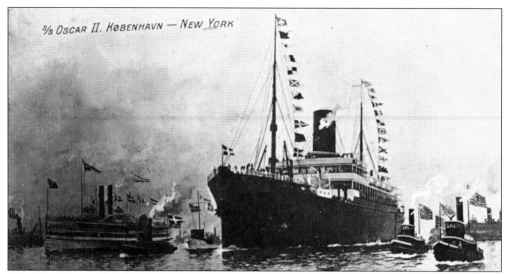

The SS *Oscar II* was one of many transatlantic ships in service during the first part of the 20th century. It was built in 1901 in Glasgow and began its maiden voyage a year later from Copenhagen, Denmark. After 1905, the ship sailed from Christiana (Oslo) directly to New York, which allowed travelers to avoid the train ride across England. Departures from Norwegian ports included Swedes from the north of Sweden. (Courtesy of Ann Baudin Stuller.)

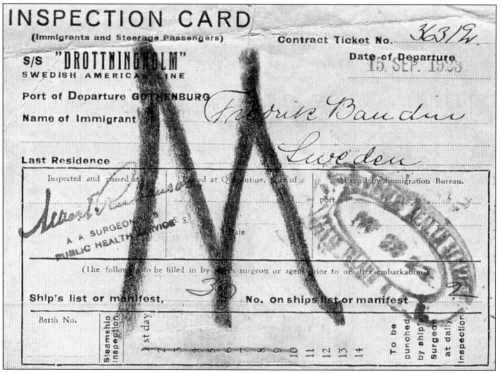

Immigrants aboard the ship had to have a health inspection daily and then undergo a final inspection at the port of debarkation. The inspection card included the person's name, their last residence and date of departure, and the contract ticket number. Also included was the ship's manifest number and the individual's number on the manifest. (Courtesy of Ann Baudin Stuller.)

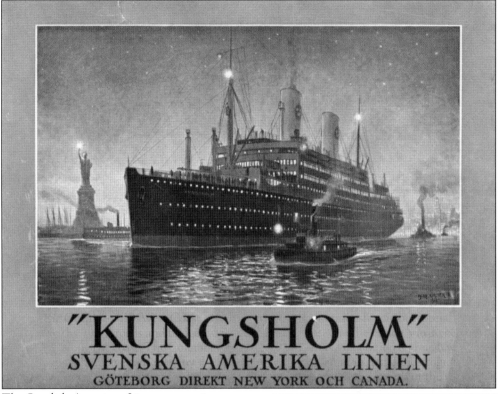

The Swedish American Line was a major Scandinavian passenger shipping line that started in 1914 (prior to the peak period of immigration to Oregon around 1923). Transport across the Atlantic Ocean was direct to New York and Canadian ports from Göteborg. This line's passenger service continued until 1975. The *Kungsholm* is pictured here in New York's harbor. (Courtesy of runeberg.org.)

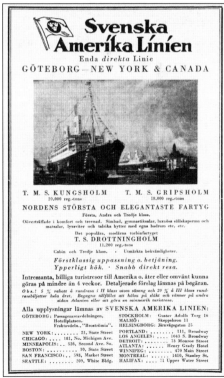

A typical advertisement for the Swedish American Line featured the *Kungsholm*, *Gripsholm*, *Stockholm*, and *Drottningholm* and the cities where tickets could be purchased, including Portland. Swedish Americans returning home to Sweden for a visit may have traveled on one of these ships in better quarters than they had during their voyage to North America. (Courtesy of runeberg.org.)

Form 2203

U. S. DEPARTMENT OF LABOR
NATURALIZATION SERVICE

TRIPLICATE
[To be given to the person making the Declaration.]

No. 9311

UNITED STATES OF AMERICA

DECLARATION OF INTENTION

☞ **Invalid for all purposes seven years after the date hereof**

UNITED STATES OF AMERICA } ss:
DISTRICT OF OREGON

In the _____ UNITED STATES DISTRICT _____ Court
of DISTRICT OF OREGON.

I, _____ Nils Conrad Grimson _____, aged __48__ years,
occupation _____ Longshoreman _____, do declare on oath that my personal
description is: Color __White__, complexion __medium__, height __5__ feet __8½__ inches,
weight __148__ pounds, color of hair __brown__, color of eyes __blue__
other visible distinctive marks _____ None. _____
I was born in __Högsjo, Sweden__ (Ångermanland)
on the __21st.,__ day of __March__, anno Domini 1 __876__; I now reside
at __1283 E. Salmon Street,__ PORTLAND, OREGON.
(Give number, street, city or town, and State.)
I emigrated to the United States of America from __Liverpool, England__
on the vessel __S. S. Lusitania__; my last
(If the alien arrived otherwise than by vessel, the character of conveyance or name of transportation company should be given)
foreign residence was __Sprangsviken, Sweden__; I am __---__ married; the name
of my {wife/husband} is __Martha Erika__; {she/he} was born at __Bjornad, Sweden__
and now resides at __Portland, Oregon__
It is my bona fide intention to renounce forever all allegiance and fidelity to any foreign
prince, potentate, state, or sovereignty, and particularly to __Gustavus V,__
__King of Sweden__, of whom I am now a subject;
I arrived at the port of _____ New York _____, in the
State of _____ New York _____, on or about the __11th.__ day
of __November__, anno Domini 1 __909__; I am not an anarchist; I am not a
polygamist nor a believer in the practice of polygamy; and it is my intention in good faith
to become a citizen of the United States of America and to permanently reside therein:
SO HELP ME GOD.

Nils Conrad Grimson
(Original signature of declarant)

Subscribed and sworn to before me in the office of the Clerk of
[SEAL] said Court this __14th__ day of __January__, anno Domini 1925

G. H. MARSH

Clerk of the UNITED STATES DISTRICT Court.
By _____ DEPUTY Clerk.

14—1170

The information concerning immigration was necessary when applying for citizenship. The last port of embarkation, the name of the ship, the port of arrival, and the date of arrival were needed. Proving those facts was made much easier by retaining all the documentation after arrival. Immigrants brought with them the skills they learned at home. Shoemakers, tailors, dressmakers, domestic workers, farmers and farm laborers, loggers, construction engineers, carpenters, fishermen, doctors, teachers—people from all walks of life contributed to the development of their new homeland. Some prospered, and some did not; most stayed, but some did not. (Courtesy of Ann Baudin Stuller.)

Two

SWEDISH SETTLEMENTS

In the early period of Swedish settlement in Oregon, direct migration from Sweden was not the rule. Most Swedes did not come to Oregon directly from Sweden but were "second stage" immigrants in that they moved to Oregon from elsewhere in the United States, largely from the Midwest—notably from Minnesota, Chicago, Kansas, and Nebraska. At first, the immigrants did not come in groups and settle in colonies but came, for the most part, as individuals and families. Toward the end of the 19th century and into the first decade of the 20th century, several communities of Swedish-speaking immigrants developed apart from those in the cities of Portland (which had the largest Swedish population), Astoria, and Coos Bay. Most of these Swedish colonies were in the northwestern portion of the state, among them Powell Valley (Gresham), Newhem (Yamhill County), Warren (Columbia County), Cherry Grove (Washington County), and Colton (Clackamas County). The one exception was around Ione in Morrow County in eastern Oregon, where the Swedish Lutheran Church, Valby, was established in 1897. Individuals and families were scattered throughout the state and made their marks in places such as Baker City (near the Idaho border), Port Orford (on the southern coast of Oregon), and Ashland (near the California border).

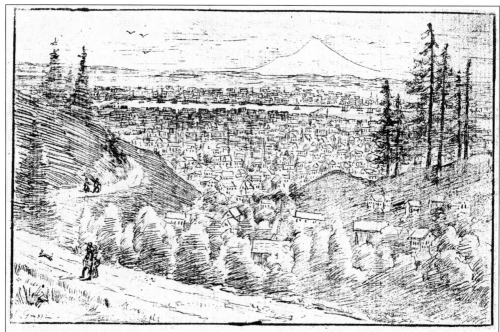

"Utsigt af staden Portland, Oregon, från vester, med Mount Hood i bakgrunden."

Portland was a frontier town when Swedes began arriving around 1850. The completion of the northern transcontinental railroad in 1883 made it easier to get to Portland from the East Coast. By the time Olof Grafström arrived in 1886, Portland was becoming a bustling city with connections to the outside world via ships and railroads. This is an Olof Grafström sketch from Ernst Skarsted's 1890 book *Vid hennes sida*. (Courtesy of Ross Fogelquist.)

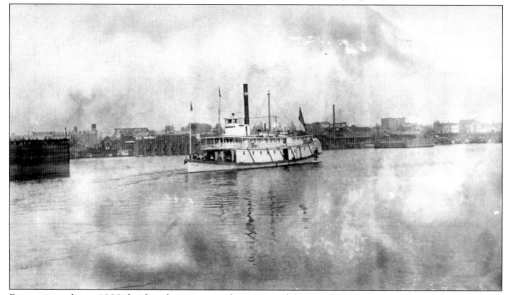

Beginning about 1888, bridges began to replace several ferries that transported people across the Willamette River. The *Lurline* was active on the Willamette and Columbia Rivers from 1878 to 1930. Portland was expanding, especially on the east side of the Willamette River, where many Swedes lived. (Courtesy of Ruth Summer.)

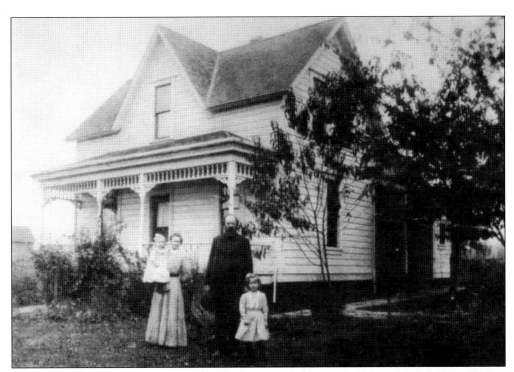

Oregon's earliest Swedish speaking community was located several miles east of Portland in Powell Valley. The area became known as the "raspberry capital of the world" through the efforts of the Gresham Fruit Growers Association and William Peterson, who arrived in 1883. Early settlers included Rev. Jonas Johnson, who is pictured above in 1908 with his wife, Selma, and their children Sigrid (standing next to her father) and Lillian (being held by her mother), who came via Spokane, Washington. At right is the tombstone for Nels Fredrick Palmquist, born in 1835 in Rumskulla, Kalmar, and his wife, Sophia Lovisa, from Kansas. (Above, courtesy of Oregon Historical Society; right, photograph by David Anderson.)

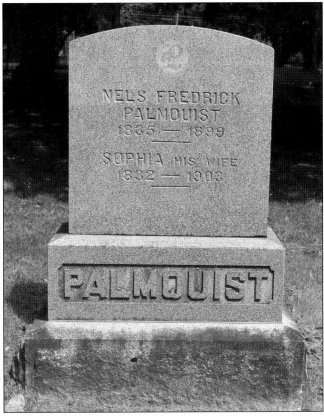

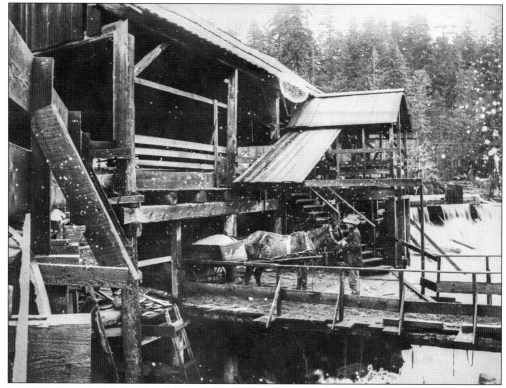

In 1906, Rev. Carl J. Renhard founded the Oregon Swedish Colonization Company, which established the Carlsborg Colony in Clackamas County in 1907. He believed Swedes would do best and be productive as farmers. The Carlsborg Colony later changed its name to Colton to be in line with the local post office. The company's goals were to encourage Swedes who were Lutheran and Republican to move to Oregon. Those who arrived first were members of the interrelated Renhard, Hult, and Chindgren (Kindgren) families, including Julius Hult, shown above (with Budweiser the mule) getting a load of sawdust at a water-powered sawmill. Marshall Dana wrote in the *Oregon Sunday Journal* on July 27, 1913, that "Oregon owes a debt to the Swede." (Above, courtesy of Oregonian Publishing Company and Oregon Historical Society; below, courtesy of Ross Fogelquist.)

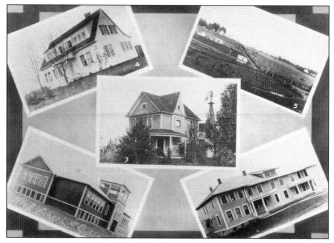

Although many families came from the Midwest, some moved north from California. Andrew Swanson, born in Sweden in 1876, was one of the settlers who had been living in California, where his oldest son Alvin J. was born around 1908. (Courtesy of David Anderson.)

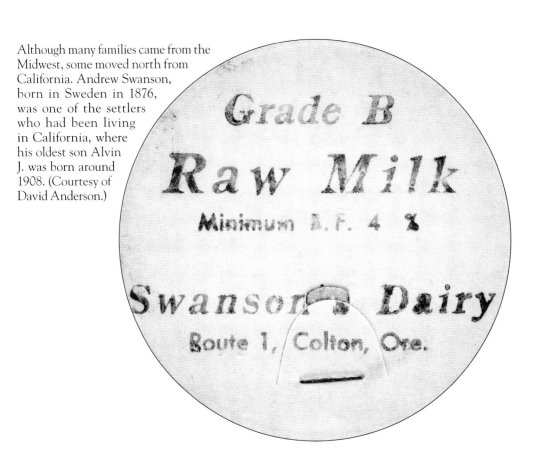

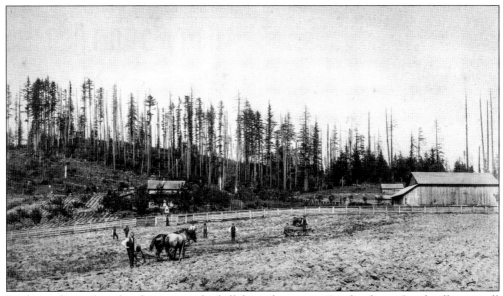

Within a few miles of and just over the hill from downtown Portland was Swedeville, a small farming community. One of the first Swedish immigrant families to arrive included Nels Nelson and his wife, Hannah, and their six children. The original school in the growing community was an old log cabin on John and Louisa Johnson's farm. (Courtesy of Oregon Historical Society.)

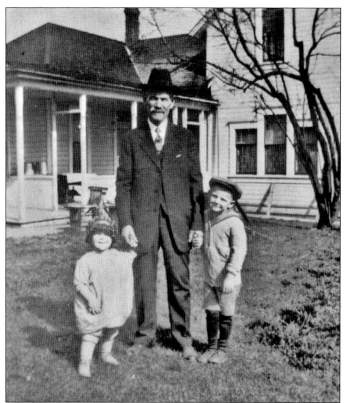

Carl J. Larson was traveling by train between Portland and Astoria and was struck by the beauty of the Warren area. In 1906, he purchased a donation land claim with a farmhouse and barns. He visualized a Swedish colony and advertised in *Oregon Posten*. He also contacted relatives and friends in the Midwest, inviting them to relocate to the community of Warren. Many responded and joined what grew to be a vibrant agricultural community centered around Bethany Lutheran Church. Larson is pictured at left with his two youngest children, Naomi (left) and Carl. (Left, courtesy of Howard and Della Larson; below, courtesy of Ross Fogelquist.)

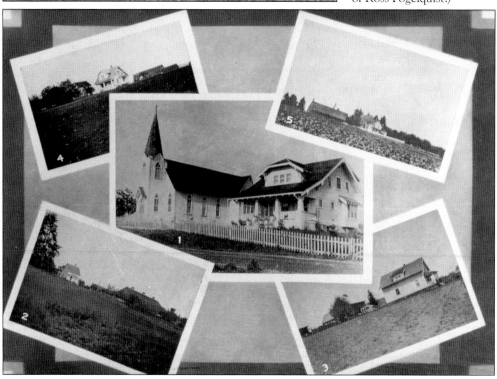

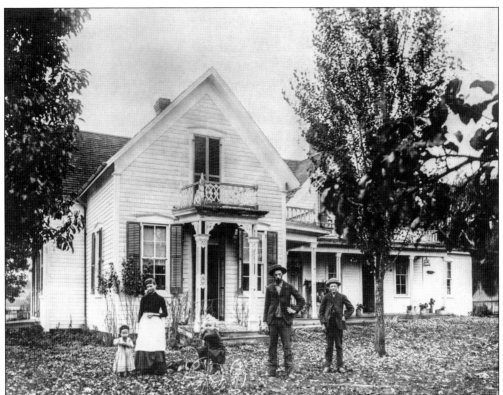

Johan Bernard "John B." Wennerberg was born in 1841 in Helsingborg in southern Sweden. At the age of 30, he immigrated to America from Australia and found his way to Yamhill County, Oregon, southwest of Portland. Wennerberg, who never married, was a successful farmer and lived his Christian ideals of helping one's neighbors; he would hire Swedish immigrants to work on his farm or give loans when assistance was needed. Some of the people who worked for him became successful farmers. One such person was Anna Collinson, who married Franz "Frank" Jernstedt. Above, Anna and Frank pose with two of their children and a neighbor boy in front of the house they were able to purchase. In the below photograph, their son Fred (born in 1888) is shown working the fields on a binder. (Both, courtesy of Oregon Historical Society).

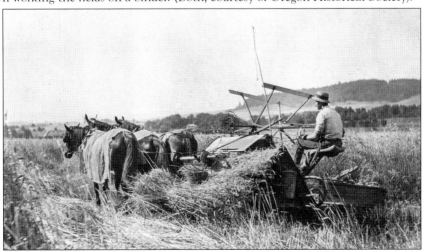

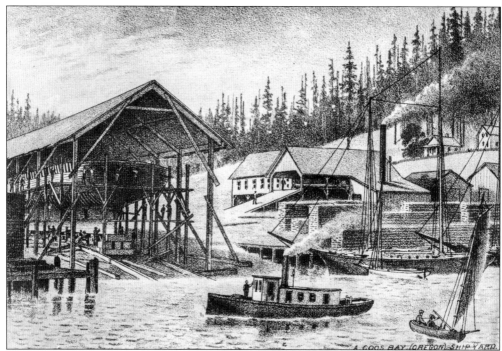

Marshfield (Coos Bay) possibly had one of the largest populations of Swedish-speaking Finns on the West Coast, plus a significant number of Swedes. There were so many Swede-Finns in Marshfield that it was sometimes called "Little Karleby" after the Karleby region of Finland (where most Swede-Finns in Oregon originated). Resource extraction provided the economic base for the area. Shipbuilding, using locally sourced forest products, was big business. The Knights of Finland hall was built, in part, using volunteer labor and dedicated in 1908. It was the location for social activities, including dances on a Rock Island maple floor. After many years of being the center of social functions, it was torn down in 1970 because it was a potential fire trap. (Above, courtesy of Oregon Historical Society; below, courtesy of the Coos History Museum, CHM 992-8-0991.)

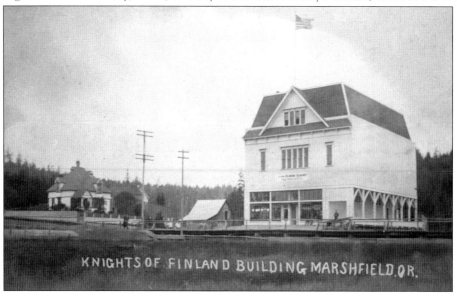

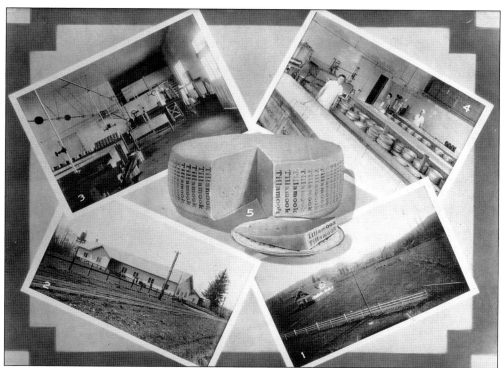

Although the Swedish communities in Tillamook County were not on the scale of those in Powell Valley or Carlsborg (Colton), a number of Swedes moved to this coastal area. The mild climate and year-round green grass for grazing made it ideal for dairy farming. In 1923, there were about 20 dairies making cheese. One of the largest of these was significantly owned by Swedish dairy farmers. (Courtesy of Ross Fogelquist.)

Among the Swedish dairy farmers in Tillamook County was Nels (Nils) Gustav Boquist (1857–1922), from Sunne, Värmland. He immigrated in 1880 to San Francisco, where he worked as a farm laborer. After his marriage to Johanna Carlsson in 1887, the couple arrived in Tillamook the same year. Around 1901, they began farming their own 160-acre homestead north of Tillamook. (Courtesy of Charline Gebhardt.)

Johanna Potentia Carlsson (1863–1938) was born in Vessinge, Halland, and immigrated to California, where she met Nels Boquist. Nels contracted typhoid fever and almost died, but she nursed him back to health. The family called her "Tentia." Today, the Tillamook Creamery Factory is located on a portion of the original Boquist homestead. (Courtesy of Charline Gebhardt.)

The Boquist family home was built in the early 1920s from logs cleared from the homestead property. The downstairs had 10-foot-high ceilings, and the upstairs ceilings stretched to 9 feet. The back section of the house was added in the 1940s and included a kitchen, nook, laundry room, and a small bathroom. (Courtesy of Charline Gebhardt.)

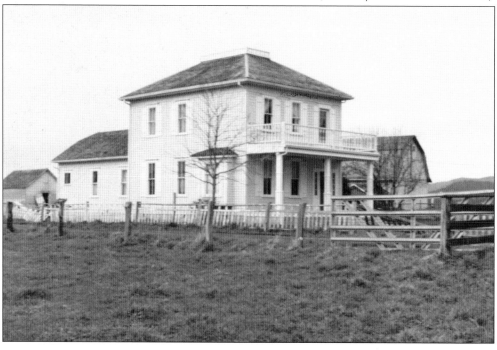

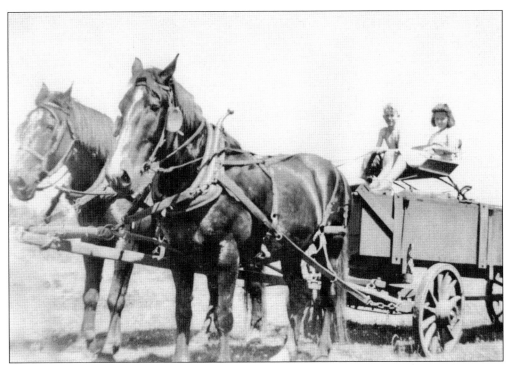

The Boquists had five sons, all born in Tillamook: Edwin, Stanley, Clarence, Alfred, and August. The homestead was eventually divided between Edwin, Alfred, and August. August's children Clarence and Joan are pictured here in 1940 in a utility wagon drawn by a team of horses. (Courtesy of Charline Gebhardt.)

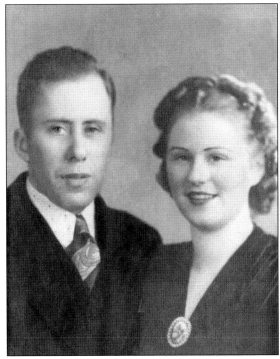

Olaf (Olof) I. Johansson (1907–1987), from Fågelfors, Kalmar, worked as a hired hand for his maternal aunt Johanna Potentia. He quickly learned how to milk a large dairy herd by hand, clear stumps and logs, fish, and make cheese. He married Thelma Pillster (1921–2018), and the couple purchased a small dairy farm after World War II. Olaf also continued working in local cheese factories. In the 1960s, he joined the board of directors of the Tillamook Dairy Association. (Courtesy of Charline Gebhardt.)

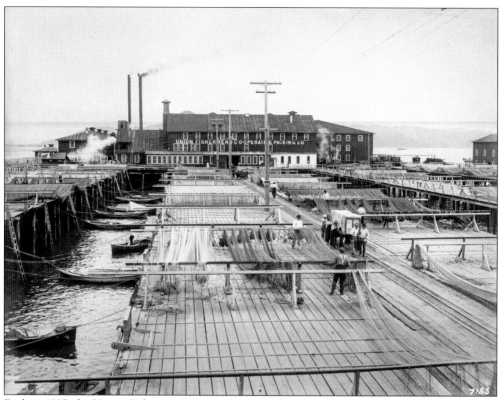

Built in 1897, the Union Fishermen's Co-operative Packing Company grew out of labor issues and allowed the fishermen to receive a fair price for their labor. Its members were mostly Scandinavian gillnetters. Between the processing plant and the shore were racks used for drying the gill nets. Next to the piers in the water are the boats used to spread the gill nets in the Columbia River to catch the migrating salmon. The sails of the small boats looked like butterflies skimming the water and gave rise to the name "butterfly fleet." This fish cannery was one of 39 canneries operating along the Columbia River in 1883. During that year, it was reported that a total of 630,000 cases, or 43 million pounds, of salmon were packed in the 39 canneries. (Above, photograph by Benjamin A. Gifford; both, courtesy of Oregon Historical Society.)

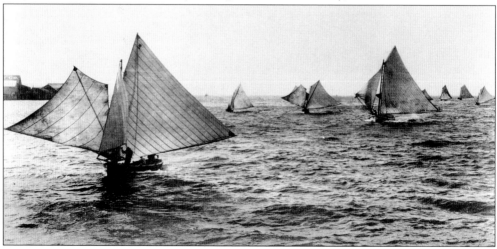

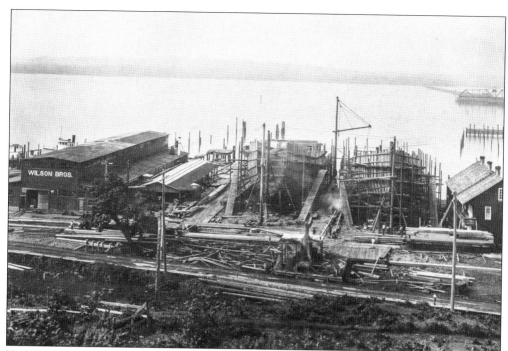

Karl Kankkonen, who was from Karleby, Vasa, Finland, immigrated to America in 1879, when he was 18 years old. He eventually found his way to Astoria, where he changed his name to Charles Wilson. He helped to form the Union Fisherman's Co-operative Packing Company. Wilson was the first person to add motors to the small boats used by gillnetters. Two of his brothers also settled in Astoria, where they were instrumental in building Taylor School and St. Mary's Hospital. St. Mary's Hospital was designed by John E. Wicks in 1905. In 1904, the Wilson Bros. shipbuilding company acceded to union demands to give their employees an eight-hour workday. The company had nearly 100 employees in 1916, and by 1918, when it was building wooden-hulled minesweepers, the number of employees totaled nearly 1,000. After World War I, the company went into decline. Two hulls that were unfinished were used in the 1927 film *Yankee Clipper*, produced by Cecil B. DeMille. (Courtesy of Oregon Historical Society.)

It is impossible to underestimate the impact the timber industry had on the influx of Swedes to Oregon. The millpond and the Hammond Lumber Mill in Astoria were once symbols of the employment opportunities that drew Swedes to Oregon in the late 19th and early 20th centuries. The millpond also provided children and dogs with a unique but rather unsafe play area. (Courtesy of Oregon Historical Society.)

The development of the fish wheel, or salmon wheel, is credited to Joel John Westerlund, a Swede-Finn from Nykarleby, Finland. He was the superintendent at Warren Packing Company in Bonneville. The fish wheel removed as much as half a ton of salmon each day from the Columbia River. After rapid declines in salmon numbers, it was outlawed in Oregon in 1926 and Washington in 1934. (Above, courtesy of Oregon Historical Society; below, courtesy of David Anderson.)

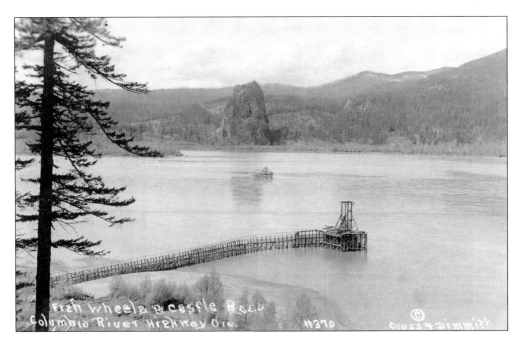

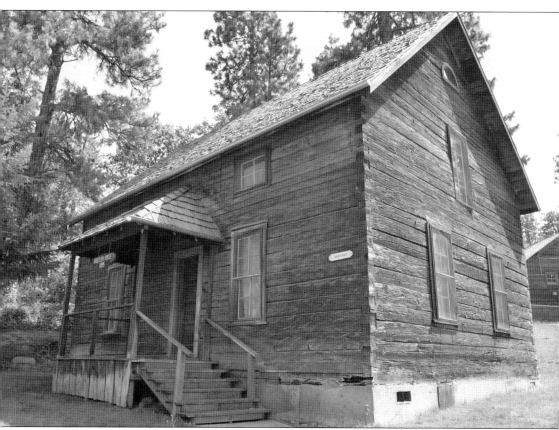

The Lewis Anderson farmhouse was originally located on Pleasant Ridge, 10 miles southwest of The Dalles. The house, an outhouse, and a barn are now located at the Fort Dalles Museum park in The Dalles. Anderson used techniques he learned in Sweden to build his large house in the rain shadow of the Oregon Cascades. (Courtesy of David Anderson.)

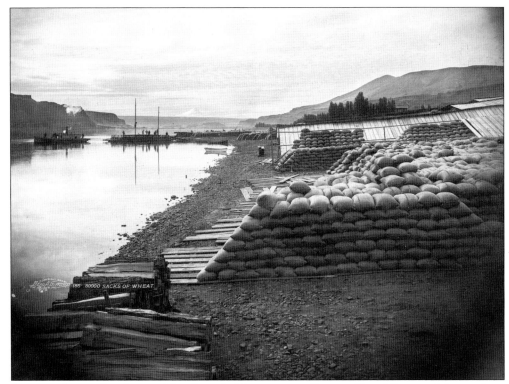

It is sparsely populated east of the Cascade Mountains in Oregon. Rainfall is much lower there than on the west side of the range. However, the high Columbia Plateau proved to be perfect for growing wheat. The area around Ione in Morrow County attracted Swedish settlers who, it is sometimes reported, thought they might try herding sheep. The wheat had to be transported on the plateau down to the river, where it would be transported to Portland, which was then the country's largest wheat-exporting port. The above photograph, captured in 1899 by Benjamin A. Gifford, was taken on the Washington side of the Columbia River to show Mount Hood. Below is a lithograph from Ernst Skarstedt's 1890 book *Oregon och Washington*. (Above, courtesy of Oregon Historical Society; below, courtesy of David Anderson.)

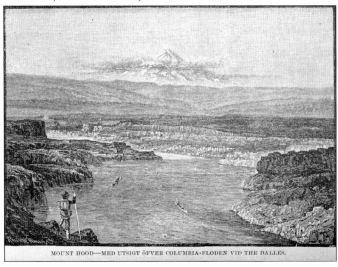

MOUNT HOOD—MED UTSIGT ÖFVER COLUMBIA-FLODEN VID THE DALLES.

Three

FROM LABORERS
TO PROFESSIONALS

At the age of 18, young Swedes would often leave home and live with another family to hone the skills they would use when they became adults. Those who grew up on farms would move to a nearby farm to work and learn from another farmer or his wife. Work and respect were demanded, and it was hard work. The young people would remain as apprentices for about two years. The first Swedish immigrants to Oregon, other than fur-trappers, were generally young, single men whose work skills were adaptable to farming, logging, and fishing. A few older men were enterprising and business-oriented, such as Charles Widberg, who opened a shoe store in Portland's early days. Those who came later were equipped with skills needed in construction of all kinds. The younger men may have started out as common laborers and acquired new skills through on-the-job experience that equipped them to become journeymen or to advance further in their chosen field. Most men came with compulsory military training, a basic education, and a desire to better themselves.

Some who arrived in the 1890s and early 1900s had been farmers in the Midwest or miners in Michigan, Colorado, Alaska, Yukon, or California. The journey west could be made by train without having to make an arduous trek over land. In Oregon, Swedes were also involved in helping to develop transportation systems that connected local communities with each other and the world beyond Oregon's borders. On the Columbia River, they helped dredge the channel and build the locks, jetties, and inland ocean port in Portland, enabling transportation and commerce to thrive. The Swedes left their marks on the landscape in the iconic bridges built in the Columbia River Gorge, in Portland, and along the coast. In Oregon, many thrived—and some died trying to do so.

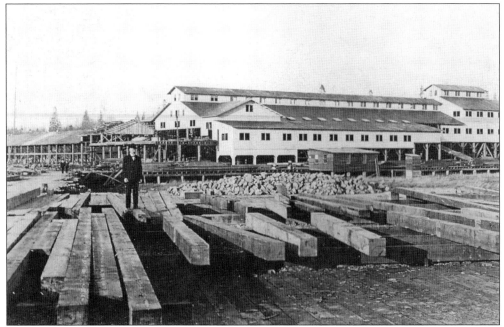

Carl Axel "C.A." Wild was born in Ekeby, Östergötland, in 1852. At the age of 15, he emigrated to America and settled in Minneapolis, Minnesota, where he changed his surname to Smith. In Minneapolis, he worked with Gov. John Pillsbury, first in a hardware store and eventually in the logging business. Smith set his sights on Coos County, Oregon, where he established the largest lumber mill in the world at the time. (Courtesy of Ross Fogelquist.)

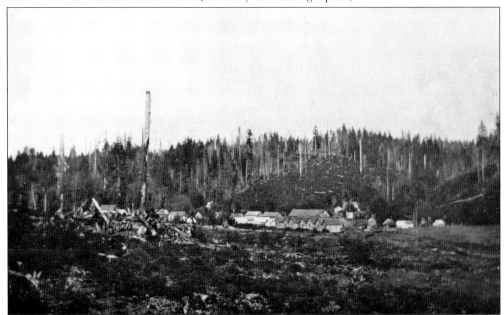

C.A. Smith never settled in Oregon but acquired a large amount of acreage, some of which he got by questionable means. His operation in Coos County included logging camps and rail lines to the mill on Coos Bay, where the logs would be rough sawn before being shipped to Bay Point on the San Francisco Bay. (Courtesy of Ross Fogelquist.)

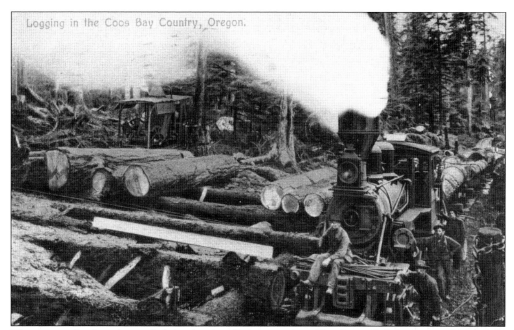

The steam donkey (upper-left background), invented in Northern California in 1880, made logging more efficient because workers no longer had to drag logs on the ground using animal power. Instead, logs were dragged to a landing next to a rail line, sawn to length, and loaded on railcars to be taken to the sawmill. (Courtesy of David Anderson.)

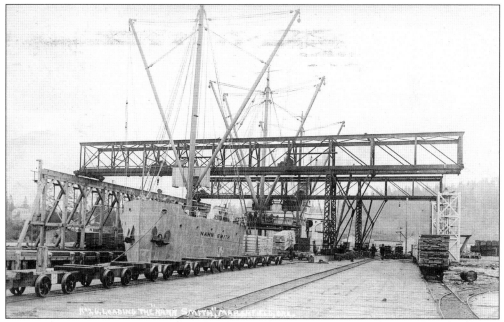

C.A. Smith had several ships built to haul the rough-sawn lumber to Bay Point in California, where it would be finished before being sent by rail to markets in the Midwest and on the East Coast. The ships were named after Smith's daughters and wife. The *Nann Smith*, named after his oldest daughter, was constructed in Virginia, sailed around Cape Horn, and arrived in Coos Bay to much fanfare in March 1908. (Courtesy of David Anderson.)

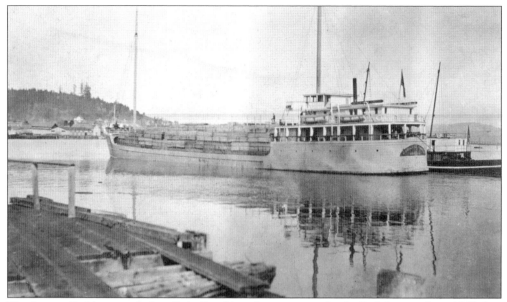

The *Joanna Smith*, named after C.A. Smith's wife, was a wooden-hulled ship made in 1917 that was one of the largest boats built in Coos Bay at the time. It was used until 1928, when it was sold. The new owner moved it south, anchored it off Long Beach, California, and used it as a gambling ship. It was seized by the federal government and mysteriously burned in 1932; the cause of the fire remains unknown. (Courtesy of David Anderson.)

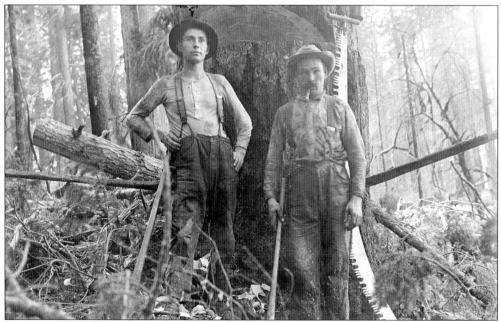

Captions on cards are frequently nonexistent, but this card is an exception. The writer, one of these two loggers, notes in Swedish that his coworker is Rikard Jakobson, who is engaged to Ingrid Lågland. This image not only provides some insight into the life of one of these workers, it also shows the environment in which they worked. (Courtesy of David Anderson.)

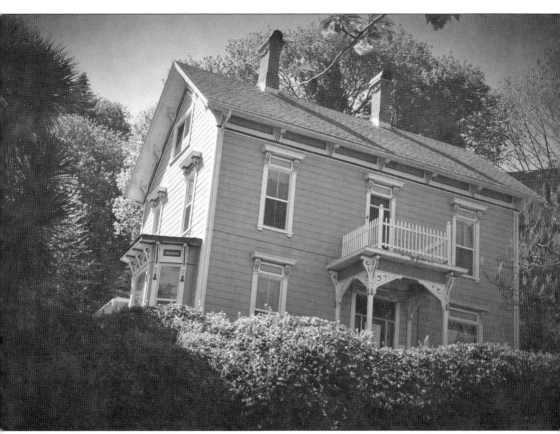

Andrew Nasburg (1839–1891) was an early pioneer in Marshfield, having left Forsa, Gävleborg, in 1850. He was active in the Masons and served as Worshipful Master about 1886. He was appointed postmaster of Marshfield in 1871 and was a charter member of Marshfield's first volunteer fire company in 1884. He became a business partner with Thomas Hirst and built the largest mercantile business in Coos County. He died in 1891 and was buried in the Marshfield Pioneer Cemetery. Andrew's older brother John, or Jonas (1830–1910), is widely reported as being one of the first Swedish settlers in Oregon after having briefly lived in Illinois. John took the overland route to Oregon—this was considered more hazardous than the ocean route, which entailed an overland crossing of the Panamanian Isthmus. John Nasburg arrived in The Dalles in 1854 and soon settled in Marshfield, where he became a saloon keeper. (Courtesy of David Anderson.)

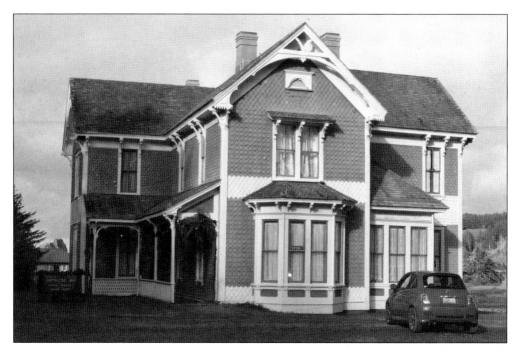

Per Johan Lindberg—or Peter John, as he became known in Oregon—was born in Uppsala, Sweden, in 1851; moved to Stockholm with his mother and sister in 1857; and found his way to Port Orford in Curry County, where he became a well-known architect. The shingles, cut in Fancy-Butt styles, on his houses created unique and decorative patterns. At least two of the surviving homes he built have never been painted since he used locally available Port Orford cedar. (Both, courtesy of David Anderson.)

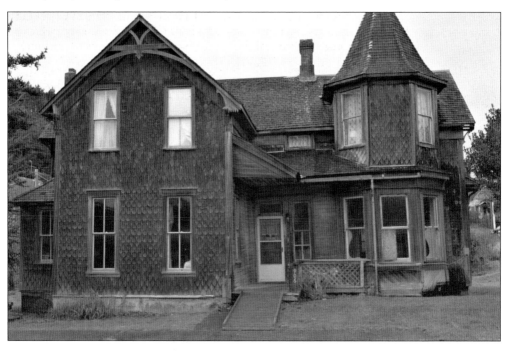

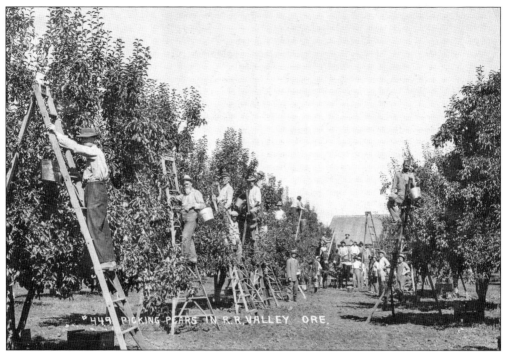

J.A. Westerlund (1865–1924) was a first-generation Swedish American born in Illinois. After his marriage to Ella C. Holmberg in 1898, the couple spent some time in Fruithurst, Alabama, before settling in Medford, Oregon. There, he started an orchard, and by 1910, he had acquired 2,300 acres. In addition to his orchard business, he was president of the Jackson County Taxpayers' League, operated the Holland Hotel in Medford, and also served as a state representative in the Oregon State Legislature for several terms. In 1910, he was part of the Commercial Club of Medford and lobbied for cities in Oregon to contribute to a fund to build a road from Medford to Crater Lake National Park. Below is a lithograph from Ernst Skarstedt's book *Oregon och Washington*, created in 1890. (Above, courtesy of Oregon Historical Society; below, courtesy of David Anderson.)

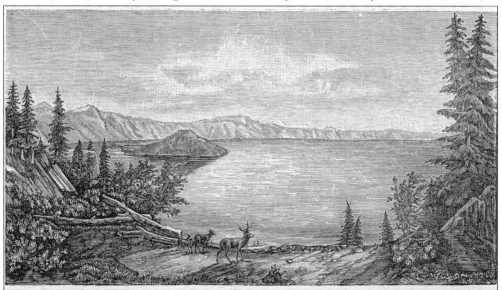

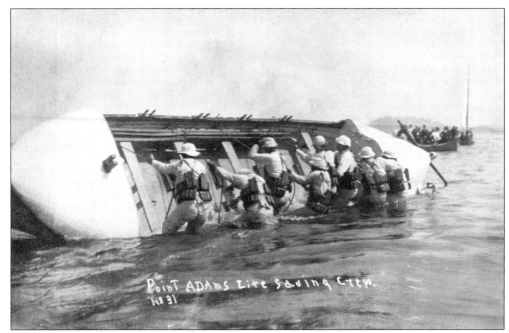

The US Life-Saving Service (USLSS) was established in 1848. In 1915, it merged with the Revenue Cutter Service to become the US Coast Guard. The purpose of the USLSS was to rescue people in trouble. In the latter half of the 19th century, the system was improved, so it was staffed by full-time crews rather than volunteers. This was tough work rowing small boats into rough seas and rescuing people floundering in the surf. Capt. Oscar Sigfrid Wicklund, a Swede, was in charge of the Point Adams Life-Saving Station on the south side of the Columbia River. His son Fanning lived at the station for a short time after his birth and was buried at the Fort Stevens Cemetery. Captain Wicklund assisted Oscar Fredrik Jacobson in setting up the life-saving station at Yaquina Bay. (Both, courtesy of David Anderson.)

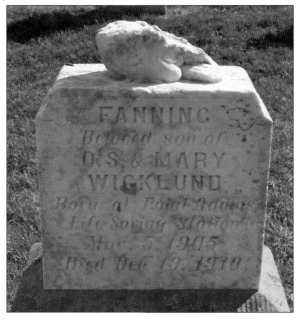

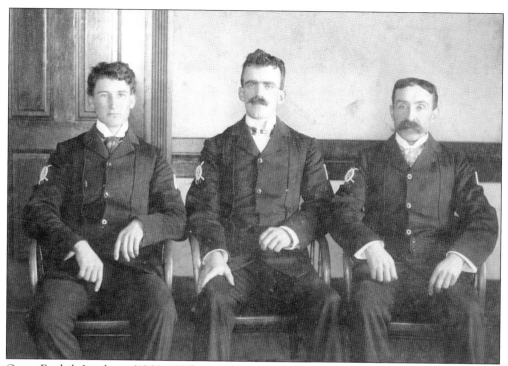

Oscar Fredrik Jacobson (1864–1935)—on the right in the above photograph and second from right, sitting with his dog at his feet, below—emigrated from Sweden in 1886. Cousins in Kansas wanted him to settle there and become a farmer, but that life was not for him. He ended up in Astoria for a short period of time, where he worked in a variety of fishing and logging jobs. In 1896, he moved to Newport and worked in the US Life-Saving Service for about four years under fellow Swede Capt. Oscar Wicklund. The US Life-Saving Service was the predecessor to the US Coast Guard. (Both, courtesy of Diane L. Glase.)

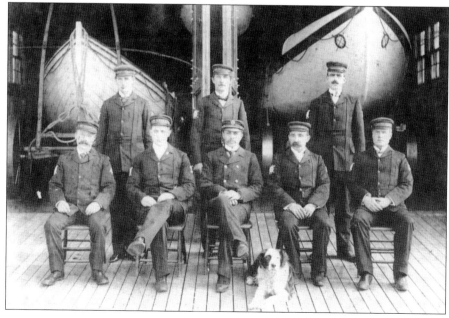

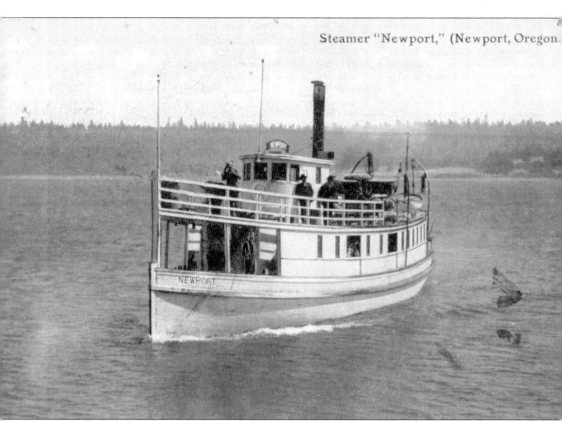

Steamer "Newport," (Newport, Oregon.

After his time with the US Life-Saving Service, O.F. Jacobson studied, earned the title of captain, and started a ferry service on Yaquina Bay and on Alsea Bay at Waldport to the south. On Yaquina Bay, the *T.M. Richardson* ran between Yaquina City, which was the terminus for the rail line from the Willamette River, and Newport. It was replaced by the larger *Newport*. Around 1924, Jacobson ran the *Sadie B* between Newport and South Beach. His sons were also involved in the ferry business, with Mike and Frank on Yaquina Bay and Eugene on Alsea Bay. Capt. O.F. Jacobson died in 1935, the year before the Yaquina Bay Bridge was built. After the bridge opened, ferry service ceased on Yaquina Bay, and a road was completed between Yaquina City and Newport. (Courtesy of David Anderson.)

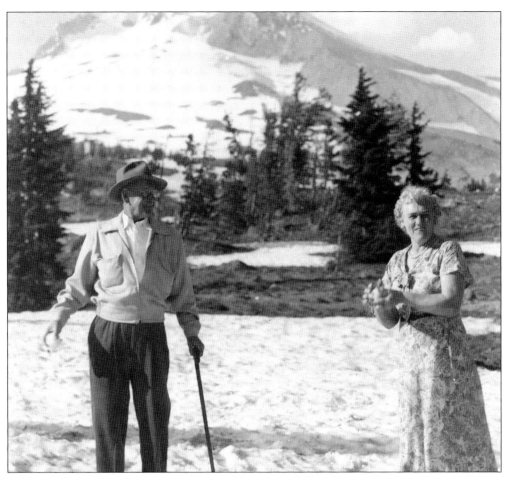

Adelina Kristina Jacobsson, shown above making a snowball on Mount Hood, was born in 1889 in Askum parish, Göteborg och Bohus, Sweden. She was the half-sister of Capt. Oscar F. Jacobson, who helped their brother Fritz in a business venture. Fritz joined with Adelina Kristina's husband, Erik Hjalmar Rendahl, in redesigning an elongated vehicle into a motor stagecoach. The stage line connected the coast of Oregon and Northern California and was later sold to Greyhound Bus lines. In the below picture, one of the coaches that started running to California after the completion of the Yaquina Bay Bridge is shown stuck in the winter mud. Rendahl, who was born in 1888 in Knista, Örebro, Sweden, designed a refrigerated truck for Consolidated Transport, which later became Consolidated Freightways. (Both, courtesy of Laura Rendahl.)

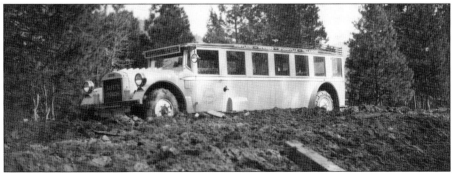

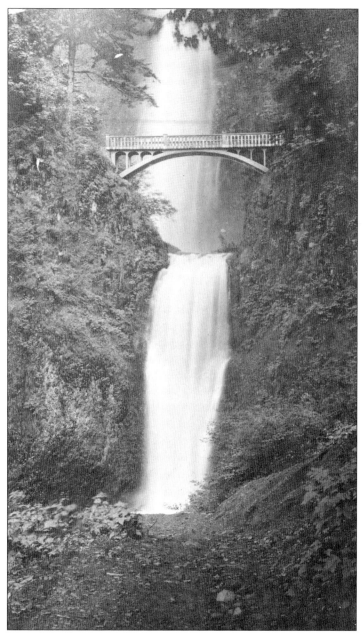

Karl P. Billner (1882–1965) only lived in Portland from 1912 to 1915 but indelibly left his mark on the state. Originally from Skåne in southern Sweden, he became the designer and engineer in charge of bridge construction along the Columbia River Highway. In the words of Samuel Lancaster in the *Morning Oregonian* on January 1, 1915, the "reinforced concrete bridges and viaducts on the Columbia Highway in Multnomah County were designed by K.P. Billner, who is entitled to full praise for his splendid accomplishments." The Simon Benson bridge above lower Multnomah Falls is a Billner-designed bridge. This bridge is probably the most photographed bridge in Oregon. Billner went on to patent a method of extracting water out of cement, allowing it to dry quicker and stronger. He lobbied the US Congress to create bomb shelters using this patented method since they would be quick to build and strong. (Courtesy of David Anderson.)

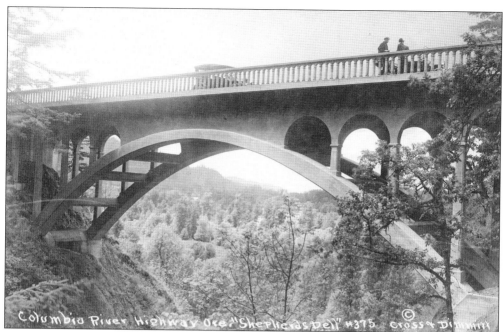

The Shepperds Dell bridge on the old Columbia River Highway is typical of Karl P. Billner's bridges, with their graceful arches spanning canyons. In 1914, Umeå-born Oscar Jonas Lindstrom formed the Lindstrom & Feigenson bridge-building company with his German-born business partner. At first, they built smaller bridges in the Mosier area at the east end of the Columbia River Gorge, where they borrowed from Billner's design. The influence of Billner's design is also obvious in the Highway 101 Alsea Bay bridge, built in 1936, for which Lindstrom & Feigenson were contractors. The Alsea Bay bridge was replaced in 1992 using a modernized design reminiscent of Billner's arching pattern. (Both, courtesy of David Anderson.)

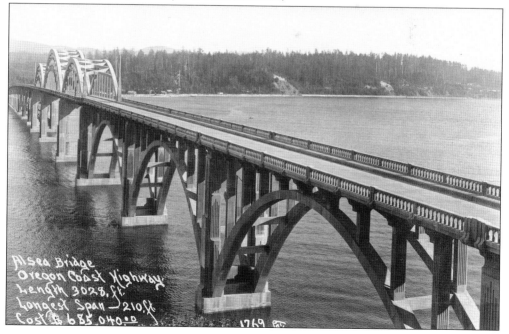

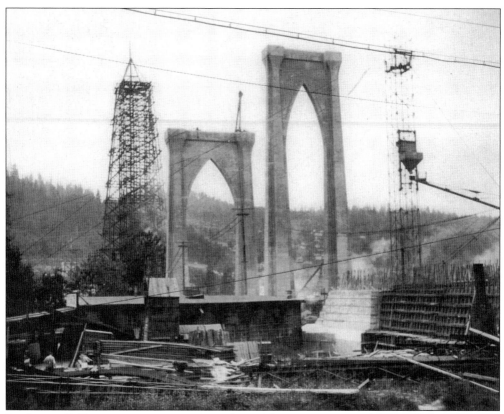

Lindstrom & Feigenson were contractors during the construction of the steel suspension St. Johns Bridge crossing the Willamette River in Portland. The bridge was constructed in 1930, at the height of the Depression. Companies involved in the construction were contractually required to employ Oregon residents. The local Labor Temple and residents complained to the Labor Commission that the contracts were not being honored. Gus Dahlin was a young Swedish immigrant living in Seattle who came to Portland seeking construction work on the bridge via one of the contractors. On November 17, 1930, he died of injuries after falling about 300 feet from one of the towers. The then-newest and tallest Portland bridge was dedicated with a lot of fanfare in 1931. (Both, courtesy of Oregon Historical Society.)

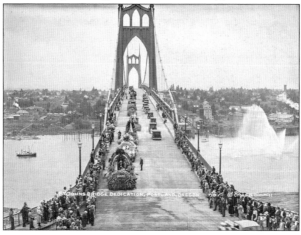

ROUGH WEATHER ON THE PACIFIC OCEAN.

The Pacific Ocean off the West Coast of North America is notoriously rough, especially in the winter months. Until roads and bridges were built, steamships were the easiest way to get to and from places along the coast. The Columbia Bar, near Astoria, has a reputation for rough water and shifting sands that have caused many shipwrecks and human fatalities. J.H. Lindstrom, who was from Helsingborg, worked on the construction of the south jetty at the mouth of the Columbia River. In April 1904, his younger brother Victor left his English wife and their children for Oregon. He found a job on the dredge *Chinook*, which maintained the Columbia River channel. Soon after arriving, Victor was hit by a train near Hammond and killed. (Above, courtesy of Ross Fogelquist; below, courtesy of David Anderson.)

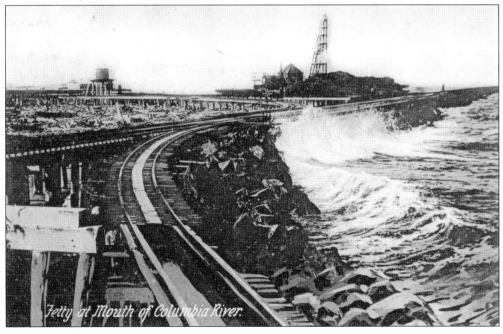

Jetty at Mouth of Columbia River.

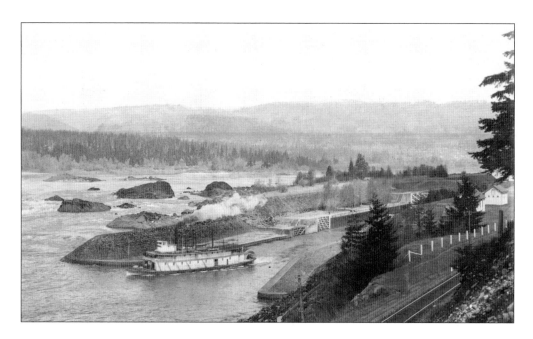

Gustave B. Hegardt was born in Skaraborg, Sweden, in 1859 to army officer Nils Josias Hegardt and Klara Ros Elisabet Jeansson. Gustave came to America in 1882 and married Mary G. Norbury in 1887 in Illinois. After moving to Oregon, he worked for the US Army Corps of Engineers on the locks at Cascade Locks on the Columbia River and as an assistant engineer in the construction of the jetties at the mouth of the Columbia River. The locks enabled ships to bypass a rough section of river formed by a large landslide and known to local Native Americans as "the Bridge of the Gods." He then became chief engineer at the Port of Portland and helped modernize the port. (Both, courtesy of David Anderson.)

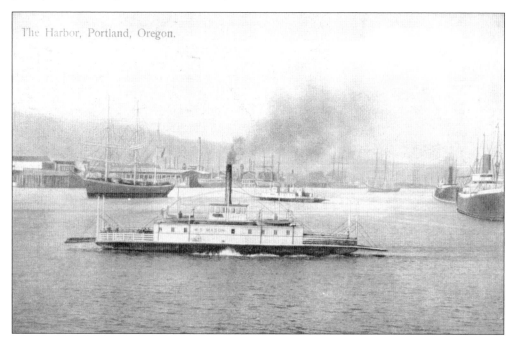

Capt. Fritz Simon Elfving, born in 1883 in Länna Parish, Uppland County, arrived in Astoria in 1907. He worked on the docks and in canneries there as a carpenter and shipbuilder. In 1912, he bought a boat and a barge and began towing people and goods across the Columbia River, keeping the ferry on schedule. Upon his retirement in 1946, he sold his business to the State of Oregon. (Courtesy of David Anderson.)

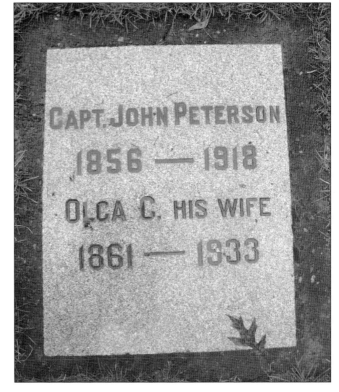

Capt. John Peterson, born in Sweden in 1856, arrived in Astoria around 1870. He commanded the steamers *Alliance* and *Dolphin*, which sailed between Grays Harbor and Portland, before he became a river pilot on the Columbia River. Captain Peterson was a longtime member of the Columbia River Pilots' Association. He and his wife, Olga, were buried in Multnomah Park Cemetery in Portland. (Courtesy of David Anderson.)

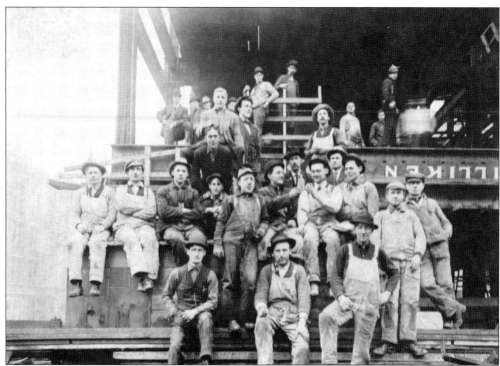

Oscar Gronquist and his brother Gustaf Adolf Gronquist arrived in North America from Dalarna, Sweden, in 1902. They worked on the Olds and King Department Store (now the Galleria) in downtown Portland in 1910. Gustaf is visible near the top of the above photograph with his arm wrapped around an upright two-by-four. The brothers also worked on the Twenty-Eighth Avenue bridge crossing Sullivans Gulch. The Portland Shipyards were busy during World War I. In the below photograph, Oscar is sitting on the far left in the first row. The second person from the left is Gustaf Adolf. To the right of Gustaf Adolf is Frank Oskar "Frankie" Gronlund, who was born in 1882 in the Vasa Municipality of Finland. Several shipyard workers died during the 1918 influenza pandemic. (Both, courtesy of Ross Fogelquist.)

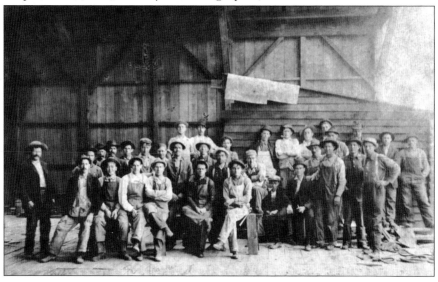

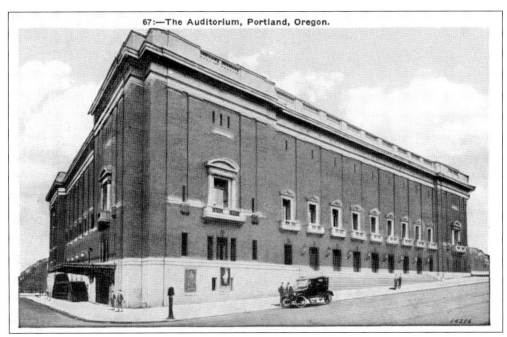

67:—The Auditorium, Portland, Oregon.

The 1918 influenza pandemic, like the 2020 COVID-19 pandemic, strained local healthcare systems across the country. Portland was no exception. The civic auditorium was used for a two-month period as a temporary hospital staffed by soldiers from the Vancouver Barracks in Washington. At least three young men of Swedish origin died in the temporary hospital. John Pearson, a ship carpenter, was 35 years old. He was buried in Rose City Cemetery. Walter Carl Kangas, a laborer, was born in Idaho in 1898; his father was Swedish, and his mother was from Finland. He was buried in Lincoln Memorial Cemetery. Albert Emanuel Rudeen, a shipbuilder, was born in Rudskoga, Värmland, in 1898 and emigrated from there in 1905 with his family. He was buried in Multnomah Park Cemetery. (Both, courtesy of David Anderson.)

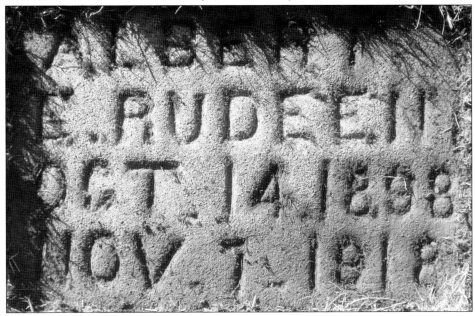

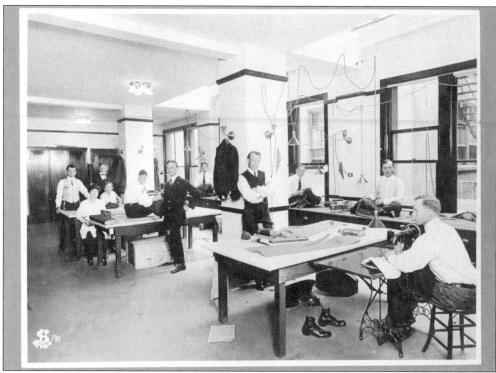

Carl Alfred Elmgren, the son of a tailor, was born in Långemåla, Kalmar, Sweden, in 1879. He lived for a time in Högsby, Kalmar, apprenticing under August Bengt Fridolf Carlberg. He, along with several of his brothers, immigrated to America and opened a tailor shop (shown above) in Portland. Gus Seaquist (1874–1958) moved to Portland from Chicago in 1911 and had come to the conclusion that Oregon was a state of "big things." On Leap Day (February 29) in 1912, one of his brood of Barred Plymouth Rock hens laid an egg bigger than he had ever seen. It measured six-and-a-half-by-eight inches in size. He wanted to show it off and took it to work, carrying it in his coat pocket. The egg made it intact, and he took great pride in crowing about it. (Both, courtesy of Ross Fogelquist.)

THE UNCONSCIOUS SOMETHING

You Will Find in the Suit That

SEAQUIST

The Tailor

MAKES FOR YOU

617 Bedell Building

Residence Phone SUnset 1349 Portland, Oregon

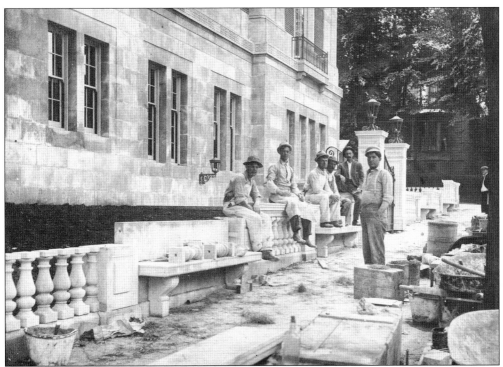

Portland Central Library, located on SW Tenth Avenue between Yamhill and Taylor Streets, was a fine addition to the city of Portland when it was completed in 1913. The library was built by Pearson Construction Company, the main partners of which were Alexander Pearson from Häverö, Stockholm, and Johan A. Bäckstrand from Bäckseda, Jönköping. Pearson was based in Seattle, and Bäckstrand lived and worked in Portland. Bäckstrand managed the library construction project, which included hiring many Swedish carpenters and stonemasons. When the library opened on September 10, 1913, it was featured on the front page of *Oregon Posten*—a page normally reserved for national news. The building featured walls of marble and oak and a central marble staircase leading to the upper floors. Portland Central Library is now part of the Multnomah County Library System. (Both, courtesy of Oregon Historical Society.)

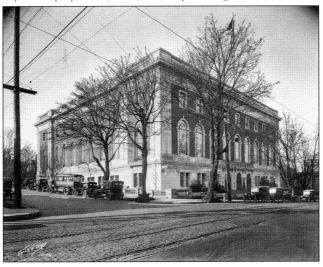

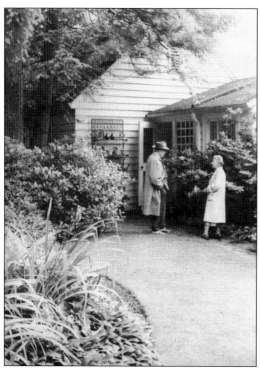

Arthur Erfeldt (1909–1993), one of Oregon's foremost landscape architects, was a first-generation Swedish American. His father, August, was from Barkåkra, Kristianstad, and his mother, Helga, was from Östergötland. Arthur completed his graduate studies at the Royal Academy of Fine Arts in Stockholm, where he also designed a number of public and private gardens. Here, he is talking with Florence Lynch in the garden he designed in 1960 in Portland. The Lynch garden is among many of his works now listed in the National Register of Historic Places. (Courtesy of the University of Oregon Library special collections.)

Arthur Erfeldt designed this spacious deck of the Cyrus Walker house, which reveals his seamless blending of Swedish and American designs, which made him important both at home and abroad. (Courtesy of Oregon Historical Society.)

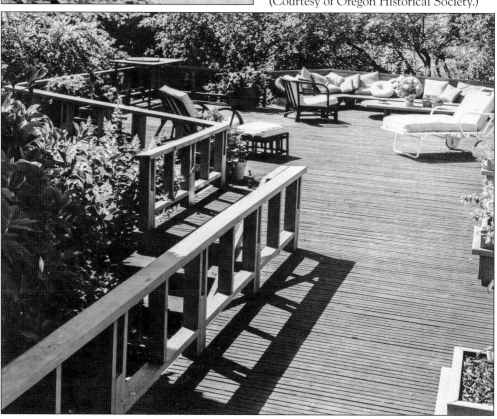

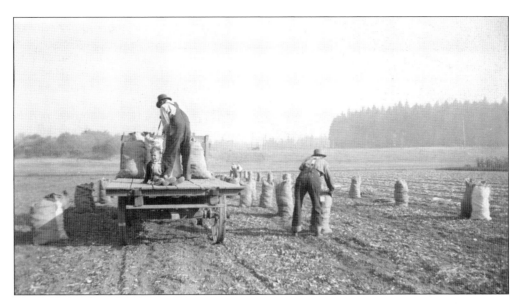

John Nyberg (1867–1954) settled in Tualatin and farmed on the banks of the Tualatin River. The farm site is now under Interstate 5, but the family name is memorialized on Nyberg Road, which runs through the area, and the Nyberg Woods Shopping Center. Nyberg, at times, raised cucumbers, which were sold to the Columbia Pickling Company of Portland, and potatoes and onions, which he grew on a 15-acre parcel. In 1924, an infestation of onion maggot damaged the yield of onions in the area. In these photographs from the family photo album, he is shown putting bagged onions on the wagon (above) and hauling the crop to market (below). In 1926, Nyberg planted mint and installed two mint stills—reputedly the largest in the state—at a cost of $1,000. Area mint growers began using his still to extract mint oil. (Both, courtesy of Christine Nyberg Tunstall.)

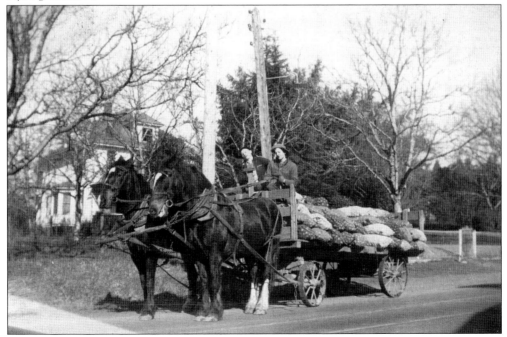

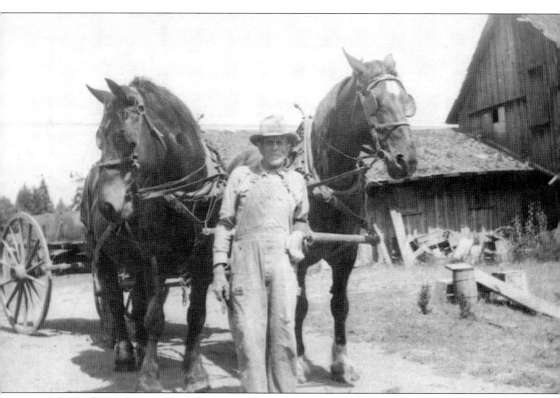

John Nyberg's favorite draft horse was the Percheron, which is well known for its intelligence and willingness to work. Nyberg was known for his skill in training draft horses and the ease he had in getting them to back up a fully loaded trailer. An accident early in life rendered his left hand deformed, but that did not stop him from farming or undertaking any other endeavor he set his mind to in his life. News stories about Nyberg and his family's activities recorded at the time can be found on the Historic Oregon Newspapers website. For example, in February 1929, during a cold spell, a frozen pond near his farm was used by local residents for ice skating, and a cow and heifer fell through the ice and drowned while trying to get a drink of water. (Courtesy of Christine Nyberg Tunstall.)

Demand for skilled craftsmen, builders, carpenters, and cabinet makers drew a number of Swedish immigrants to Portland and, to a lesser degree, Astoria and Coos Bay on the Oregon coast. Among the Swedish contractors in Portland in 1923 were Herman Nelson and his brothers Oscar and Emil. Others included Edvard J. Grähs, August Malmquist, and Nils O. Eklund. Some of the homes built by Eklund are pictured here. (Courtesy of Ross Fogelquist.)

Herman Nelson's advertisement was placed in the 1929 Midsummer program sponsored by the League of Swedish Societies in Portland. These event programs and *Oregon Posten* provided opportunities to appeal directly to the Swedish community. (Courtesy of Ross Fogelquist.)

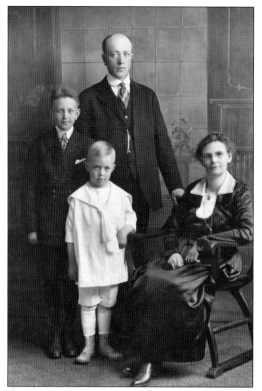

Herman Nelson (Nilsson) was born in Överkalix, Norrbotten, and immigrated to Michigan in 1904, later settling in the Portland area. He married Hilma Carolina Peterson (1872–1954) from Norra Lövfallet, Örebro. Their children were Kenneth (1910–2007) and Arthur (1914–1998). Herman was a residential home builder, and Kenneth followed in his father's occupation. They built many homes in Portland, chiefly on Portland's east side. Herman and Hilma were married by Benedictus J. Thorén, pastor of the Swedish Mission Covenant Church in northwest Portland, on October 3, 1908. The wedding certificate is in English, but no doubt, the ceremony was conducted in Swedish by Pastor Thorén. Incidentally, October 3 also became the wedding date of their son Kenneth and his wife, Mary Grimson, 29 years later. (Both, courtesy of Ann Baudin Stuller.)

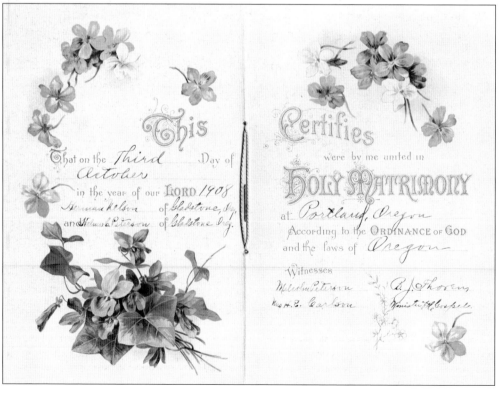

Herman Nelson built his family's first home in Gladstone, Oregon, where this photograph was taken in 1912. To the right of the steps are Hilma (Herman's wife) and Herman. The small child is their son Kenneth. The house was of wood construction in a two-story bungalow style with a porch across the front. (Courtesy of Ann Baudin Stuller.)

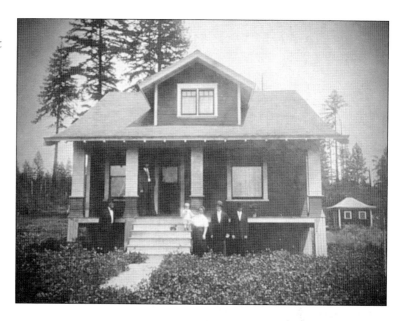

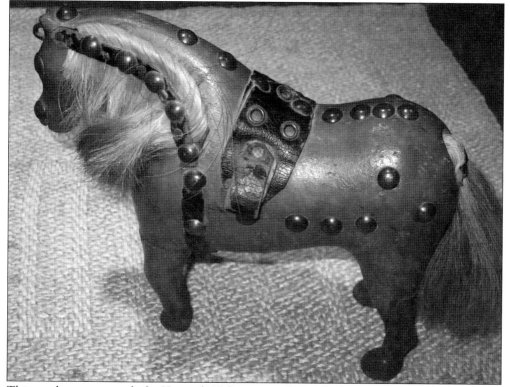

This toy horse was made for Kenneth Nelson around 1910 by his grandfather, Anton Albert Nilsson (1845–1920), who sent it from Sweden when he learned of Kenneth's birth. Leather and nailheads were used for decoration and gave it extra weight. The mane and tail are made of horsehair. At least two generations used it as it was originally intended, with little damage to the original construction. (Courtesy of Larry K. Nelson.)

Nils Conrad Grimson (Grimsen) was born in Västernorrland in 1876. In 1909, Conrad came to Portland, Oregon, where he had relatives, after the tragic death of a younger brother who was working at the local mill in Sprängsviken. Conrad stated that he could no longer work where his brother had died. Once he arrived in Oregon, he began working at a sawmill in Scappoose on the Columbia River. Conrad is pictured second from left in the above image. Later, he was able to send passage for his wife, Martha Näsholm, and their daughter Martha Stina in Sweden. He eventually became a longshoreman in Portland and had an additional daughter, Mary; a house and a car; and a good life in the Mount Tabor district. Below, Mary is between Conrad and his wife, Martha, and Martha Stina is standing behind them. (Both, courtesy of Ann Baudin Stuller.)

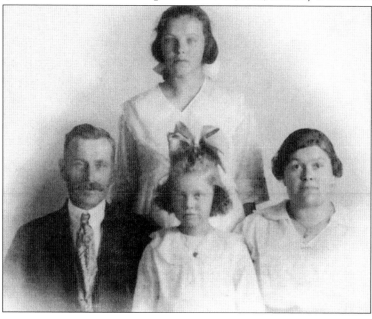

OREGON STATE BOARD OF HEALTH 2706

CERTIFICATE OF DEATH

1 PLACE OF DEATH	State Registered No.
County _Mult_ State _Ore_	Local Registered No. **197**
Township	or Village _____ or
City _Portland_ No. _Good Sam Hospt_ St. _____ Ward	
(If death occurred in a hospital or institution, give its name instead of street and number)	

2 FULL NAME _Nils Conrad Grimson_

(a) Residence. No. _1283 E. Salmon_ St.,

(Usual place of abode) (If nonresident, give city or town and state)

Length of residence in city or town where death occurred _5_ yrs. mos. ds. How long in U. S., if of foreign birth _25_ yrs. mos. da.

PERSONAL AND STATISTICAL PARTICULARS	CORONER'S CERTIFICATE OF DEATH
3 SEX _Male_ 4 COLOR OR RACE _White_ 5 Single, Married, Widowed or divorced (write the word) _Married_	16 DATE OF DEATH (month, day, and year) _Oct 22_ 19 _25_
5a If married, widowed, or divorced HUSBAND of (or) WIFE of _Martha_	17 I HEREBY CERTIFY, That I took charge of the remains described above, held an _Inquiry_ (Inquest, Autopsy or Inquiry) thereon
6 DATE OF BIRTH (month, day, and year) _Mar 21-1876_	and from the evidence obtained by _Inquiry_ (Inquest, Autopsy or Inquiry)
7 AGE Years _49_ Months _7_ Days _1_ If less than 1 day, ___ hrs. or ___ min.	find that said deceased came to _his_ death on the day stated above.
8 OCCUPATION OF DECEASED (a) Trade, profession, or particular kind of work _Stevedore_	The CAUSE OF DEATH was as follows: _Traumatic fracture of the skull_
(b) General nature of industry, business, or establishment in which employed (or employer)	_Crushing of chest_
(c) Name of employer	(duration) yrs. mos. days.
9 BIRTHPLACE (city or town) (State or country) _Sweden_	CONTRIBUTORY (Secondary) _Due to lumber falling on him_
10 NAME OF FATHER _Peter A Grimson_	(duration) yrs. mos. days.
11 BIRTHPLACE OF FATHER (city or town) (State or country) _Norway_	18 (Signed) _H T Barton_ , M. D.
12 MAIDEN NAME OF MOTHER _Christine Petterson_	(Examining physician) _Earl Smith_
13 BIRTHPLACE OF MOTHER (city or town) (State or country) _Sweden_	_Oct 24_ 19 _25_ By _Dm Earl Franson_ (Coroner) (Address) _Deputy_
14 Informant _Mrs Martha Grimson_ (Address) _1283 E Salmon St_	* State the Disease Causing Death, or in deaths from Violent Causes, state (1) Means and Nature of Injury, and (2) whether Accidental, Suicidal, or Homicidal. (See reverse side for additional space.)
15 Filed _10-29_ 19 _25_ _S J O'Dell_ Registrar.	19 PLACE OF BURIAL, CREMATION OR REMOVAL _Rose City Cem_ DATE OF BURIAL _Oct 24_ 19 _25_
	20 UNDERTAKER _Pearson Und Co_ ADDRESS _City_

On October 22, 1925, while Conrad Grimson was at work, a crane operator was loading lumber, and Conrad suffered a fate similar to that of his brother who had died while working at a mill in Sweden. The lumber fell on Conrad Grimson, fracturing his skull and crushing his chest. The death announcement states, in Swedish: "My beloved husband died after an accident at the age of forty-nine years, seven months, and one day. He leaves a wife, two daughters, and one brother in Portland together with his parents and brothers and sisters in Sweden." He was buried at Rose City Cemetery in Portland, where many Swedes are interred. (Courtesy of Ann Baudin Stuller.)

Härmed tillkännagives

att min älskade make

Nils Conrad Grimson

i följd av olyckshändelse stilla och fridfullt av-
led i Portland, Oregon, 22 Oktober 1925 i
en ålder av 49 år 7 månader och 1 dag, efter-
lämnande maka, två döttrar, Martha och Mary,
en broder i Portland samt åldriga föräldrar
och syskon i Sverige, lämnande oss i den djup-
aste sorg.

Mrs. Martha Grimson

John Wicks (Johan Erik Wiik) was born on July 13, 1878, in Kvevlax, Korsholm, Finland. He immigrated to the United States in 1899, received an education at Bethany College in Lindsborg, Kansas, and established himself as an architect in Astoria, Oregon, in 1904. When Oregon began to license architects in 1919, he was the third one to receive a license. He served on the first Board of Architect Examiners and became board president in 1935. His influence in Astoria was significant as he had more involvement with the design of buildings and residences there than perhaps any other architect. His daughter Ebba also became an architect and was well-known in her own right. Above is the First Baptist Church in Astoria, which is one of his more traditional designs. Below is a detail of the front entrance at his family home in Astoria. (Both, courtesy of Ann Baudin Stuller.)

The sign on the building that occupied nearly an entire city block said, "Working Man's Club"—this was Erickson's Saloon on West Burnside Street, two blocks from the Willamette River. It was founded in the early 1880s by August "Gus" Erickson, a Swede-Finn from Helsinki. The saloon had a reputation as big as the establishment itself, with a bar that was as long as the city block, 60 bartenders working in two shifts, gaming rooms, and a theater that featured dancing ladies with painted faces. The often rough customers trusted Erickson's with their payrolls and frequently spent much of them there. In the photograph at right, Erickson is reading a copy of *Oregon Posten*, while in the photograph below, he is the mustachioed man standing among his saloon staff. (Right, courtesy of Oregonian Publishing Company and Oregon Historical Society; below, courtesy of Oregon Historical Society.)

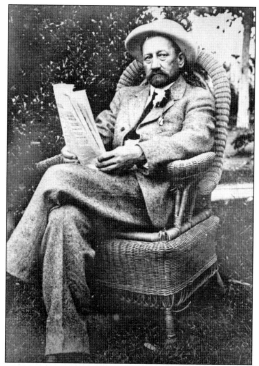

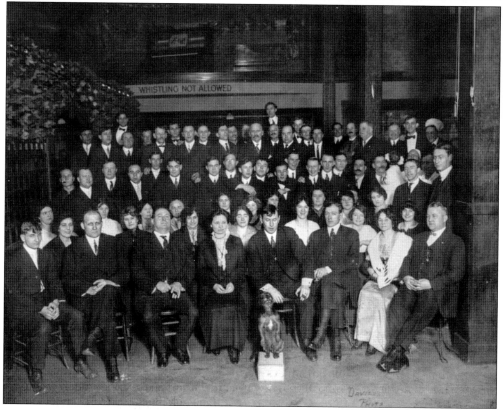

A number of Swedish immigrants became well-known educators in Oregon who were also on the faculties of institutions of higher learning. John Andrew Johnson Bexell (Johan Anders Svensson) was born in Bexet, Färgaryd, Jönköping, in 1867. He came to Oregon Agricultural College (now Oregon State University) in 1908 as an expert in agricultural economics and served as dean of the School of Commerce. Bexell Hall on the Oregon State University campus was named in his honor in 1966. (Courtesy of Oregonian Publishing Company and Oregon Historical Society.)

Olof Larsell was born in Rättvik, Dalarna, in 1886. He was a graduate of Linfield College and Northwestern University. He served on the faculties of both schools and, from 1921 to 1952, was a professor and chairman of the Department of Anatomy at the University of Oregon Medical School (now Oregon Health Sciences University.) Dr. Larsell was a biologist, anatomist, and historian. A building on the Linfield campus is named for him. (Courtesy of Oregonian Publishing Company and Oregon Historical Society.)

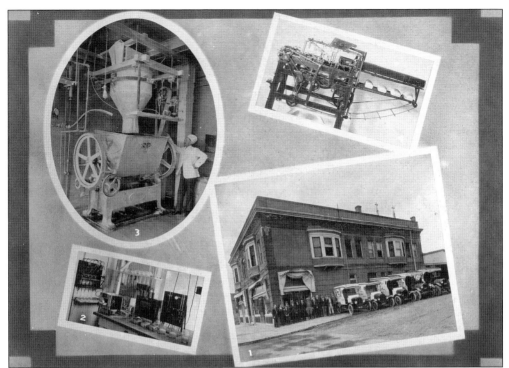

Viking Bakery Company began on Portland's east side around 1913. The director of the bakery was A.H. Sanden from Linköping, born in 1875. The photographs show (1) the exterior of the building with some employees and delivery trucks, (2) a corner of the bakery, (3) a bread-kneading machine, and (4) a bread-wrapping machine. The bakery was located at SE Stark Street and Thirteenth Avenue. These photographs were taken in 1923. (Courtesy of Ross Fogelquist.)

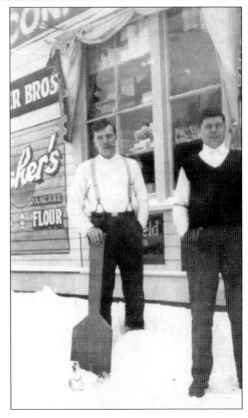

Jakob "Jack" Soder and his younger brother Magnus Nils were born in Offerdal, Jämtland. After immigrating, Jack worked as a blacksmith in Portland in 1920. Magnus earned a living as a camp cook. Eventually, they set up shop at the corner of SE Seventh Avenue and Miller Street, where they operated the Soder Brothers Grocery and Confectionary in Sellwood. (Courtesy of Ross Fogelquist.)

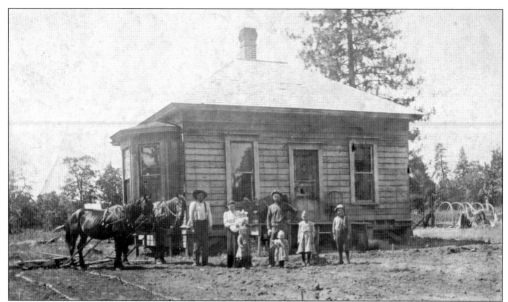

Pehr Adolf Löfgren was born in 1868 in Ovanåker, Gävleborg, and emigrated from Voxna, Gävleborg, in 1886. In 1893, he married his wife, Ruth Laura Myrtle Feezer, in Colorado. The family of nine moved around a lot as required by Löfgren's work. This photograph from 1904 shows Löfgren (next to the horses), his wife and children, and a brother-in-law in front of their Hood River County home. (Courtesy of David Anderson.)

John Erickson (Johan Eriksson) was born in Blomskog, Värmland, in 1868. He first settled in Minneapolis after immigrating in 1902. By 1912, he was responsible for photographing events in the Swedish community in Portland, where he had a studio. He also did individual and family portraits, and his work can be recognized in many Swedish American family collections that originated in Portland. (Courtesy of Ross Fogelquist.)

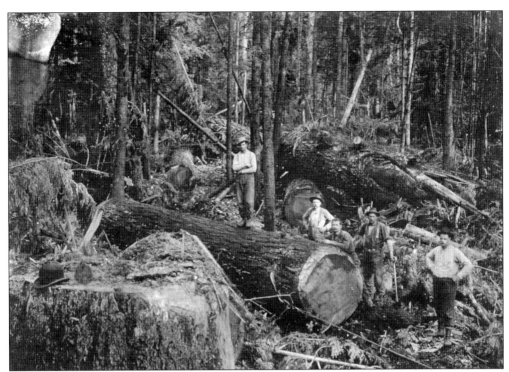

Herman Olsson (1867–1947), standing to the right of the giant Douglas fir logs, was from Forshälla, Västergötland. He worked in Clatsop and Columbia Counties during the first part of the 20th century before eventually returning home to family in Sweden, where he had a farm. Olsson began as a railroad worker and logger, later advancing to become the foreman of an 80-man crew near the lower Columbia River. Both of these images are part of a series of logging photographs taken by John Fletcher Ford in Oregon forests from 1900 to 1908. (Both, photograph by J.F. Ford; courtesy of Unnie Malmén.)

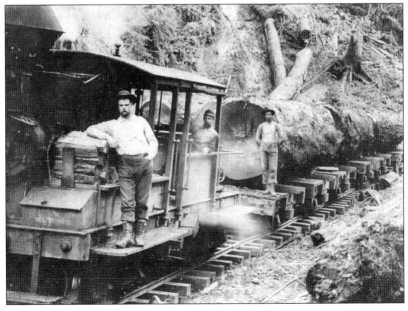

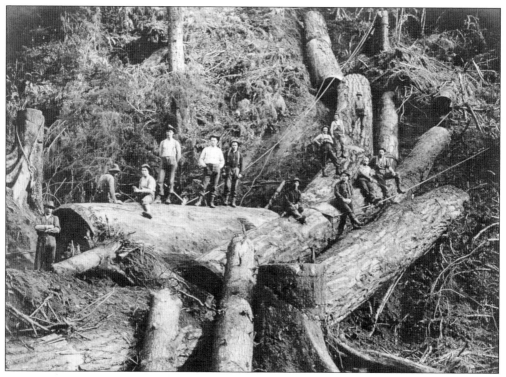

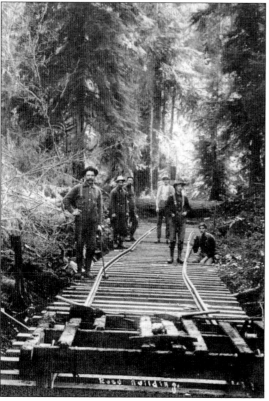

Herman Olsson, in a white shirt, is standing on a Douglas fir log with part of the crew he supervised. John Fletcher Ford's photographs recorded the harvesting of the giant trees that populated the old-growth forests of northwestern Oregon, especially in Clatsop County, which was bordered by the Pacific Ocean to the west and Columbia River to the north. (Photograph by J.F. Ford, courtesy of Unnie Malmén.)

This crew was building temporary tracks for transporting logs. These tracks allowed for the harvesting of logs deep in the forests far from other means of transportation. Once the logs reached a landing by a river, they could be floated to nearby sawmills and transformed into lumber. (Photograph by J.F. Ford, courtesy of Unnie Malmén.)

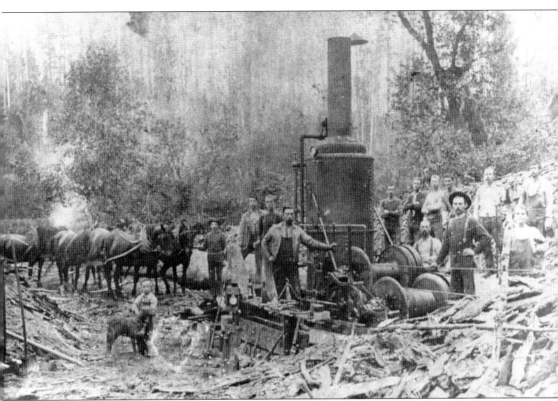

Once a tree was cut, teams of horses or oxen were used to pull, or skid, the logs to the railroads. A log puller, or steam donkey, was used to move the logs by attaching the logs to a cable and dragging it. The steam donkey was built on skids so it could be moved by attaching a cable to a tree or stump, then winding the cable on the powered winch, which would pull the steam donkey to where it was needed. Steam donkeys became obsolete after the invention of the diesel engine. A few steam donkeys are now exhibited in museums. (Photograph by J.F. Ford, courtesy of Unnie Malmén.)

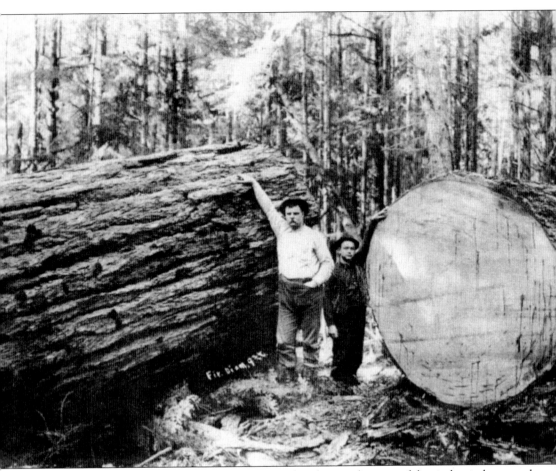

Many Swedes who settled in Oregon were attracted to the state because of the timber industry and the jobs it offered. Swedish loggers were amazed at the size of the trees, since they were accustomed to trees much smaller in diameter. To them, a Douglas fir tree—at nine feet in diameter—was unthinkable. It is small wonder that Herman Olsson returned to Sweden with Ford's photographs as proof of his experiences in Oregon. He knew firsthand the dangers and injuries loggers faced on a daily basis. (Photograph by J.F. Ford, courtesy of Unnie Malmén.)

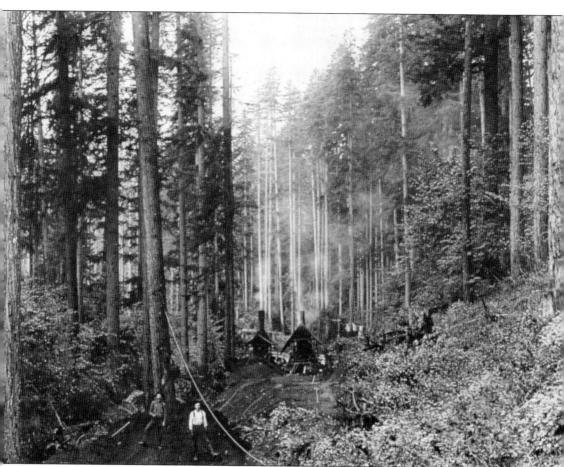

At the end of the 19th century, the forest west of the Cascade Mountain range summit was composed of a tall, large mixed coniferous forest. Douglas fir is the dominant tree. Other species, including Sitka spruce found along the immediate coast, are also important. The spruce was valued for its strength and durability and was heavily logged for use in the manufacturing of planes during World War I. (Photograph by J.F. Ford, courtesy of Unnie Malmén.)

Caulked (pronounced "corked") logger's boots, as well as a good crosscut saw and ax, were essential elements of a logger's basic equipment. The boots provided traction on wet logs, especially when timber rafting. The pair shown being caulked was made at the Bergmann Shoe Manufacturing Company in Portland, which was started by Theodore Bergmann, a native of Germany. Gus Swanson (second from left in the below image) is wearing a pair of logger's boots in the 1950s around Grand Ronde, Oregon. Swanson was married to Marie Olson, the 1928 midsummer queen (see chapter 8). (Left, courtesy of Oregon Historical Society; below, courtesy of Suzanne Lindberg Nelson.)

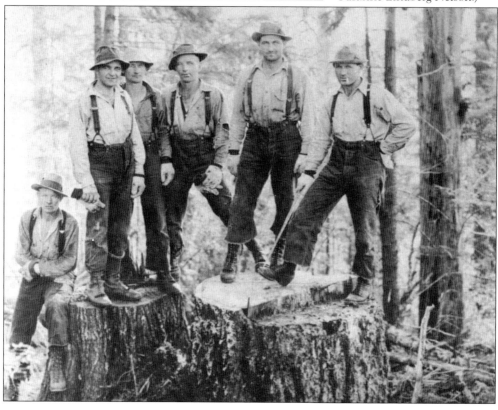

Form S-19

1. PLACE OF DEATH

County *Wahkiakum*

PORTLAND, OREGON
BUREAU OF VITAL STATISTICS
STANDARD CERTIFICATE OF DEATH

Registered No. *217*

[If death occurred in a Hospital or Institution, give its NAME instead of street and number and fill out No. 18.]

Town of
or City of *Grays River* No. *Grays River, Wash.* Street

2. FULL NAME *Carl Berg*

PERSONAL AND STATISTICAL PARTICULARS | MEDICAL CERTIFICATE OF DEATH

3 SEX *male* 4 COLOR OR RACE *White* 5 SINGLE, MARRIED, WIDOWED OR DIVORCED (Write the Word) *single*

16 DATE OF DEATH *March 23* 191*7* (Month) (Day) (Year)

6 DATE OF BIRTH *Oct 31* 188*6* (Month) (Day) (Year)

7 AGE *30* years, *4* months, *53* days IF LESS than 1 day, ...hrs. or ...min.

17 I HEREBY CERTIFY, That I attended deceased from ...191..., to ...191...
that I last saw h... alive on ...191...
and that death occurred, on the date stated above, at ...M.
The CAUSE OF DEATH was as follows:
accidental fracture of skull

8 OCCUPATION (a) Trade, profession or particular kind of work, *Laborer* (b) General nature of Industry, business or establishment in which employed (or employer)

9 BIRTHPLACE (State or Country) *Sweden*

10 NAME OF FATHER *not known*

11 BIRTHPLACE OF FATHER (State or Country) *Sweden*

12 MAIDEN NAME OF MOTHER *not known*

13 BIRTHPLACE OF MOTHER (State or Country) *Sweden*

...(Duration) ...yrs. ...mos. ...dys.
Contributory ...
Secondary ...(Duration) ...yrs. ...mos. ...dys.
(Signed) *William S. Nixon* M.D.
Mar 25 191*7* Address *Astoria, Ore.*

State the DISEASE CAUSING DEATH, or, in deaths from VIOLENT CAUSES state (1) MEANS OF INJURY and (2) whether ACCIDENTAL, SUICIDAL, or HOMICIDAL.

13a LENGTH OF RESIDENCE
At Place of Death ...years *1* months
In Oregon *2* years ...months

18 SPECIAL INFORMATION only for Hospitals, Institutions, Transients, or Recent Residents.
Former or Usual Residence ...
Where was disease contracted, if not at Place of Death? ...
How long at Place of Death? ...Dys.

14 THE ABOVE IS TRUE TO THE BEST OF MY KNOWLEDGE
(Informant) ...
(Address) *111 Maythly*

19 PLACE OF BURIAL OR REMOVAL *Mult Cem* DATE OF BURIAL *Mar 28* 191*7*
20 UNDERTAKER *Pearson Co* ADDRESS *369-91 Russell*

15 Filed *3/26* 191*7* *Marcellus* Registrar or Deputy.

Logging was—and is—a dangerous occupation: cables snap, trees roll unexpectedly, and tree limbs break off and fall. The Grays River incident on March 23, 1917, was one of the deadliest, and at least 11 men were killed. The loggers were riding railroad flatbed cars back to camp when a storm blew over an 18-inch-diameter hemlock. The dead and injured survivors were taken across the river to St. Mary's Hospital in Astoria (shown below). Carl Berg, age 30, from Misterhult, Kalmar, had been in Oregon for only two years and was buried in Multnomah Park Cemetery in Portland. Axel Dahleen, age 35, was born in Vimmerby, Kalmar, and buried in Rose City Cemetery in Portland. Both are in unmarked graves. (Above, courtesy of Oregon State Archives, Salem; below, courtesy of David Anderson.)

First-generation Swedish American Elmer Olson (right), pictured with his friend Ed Moyer, is shown enjoying summer swimming at Oaks Park. Charles Elmer Olson (his birth name) was born in North Dakota in 1884. His father was born in Bo, Örebro, while his mother was born in Virserum, Kalmar. Oaks Park is an amusement park established along one of the commuter lines to encourage people to take public transportation to a recreation site. The ferry *John F. Caples* was funded in 1903 and ran from the foot of Spokane Street, close to Oaks Park, across the Willamette until the Sellwood Bridge was built in 1925. (Both, courtesy of Ruth Summers.)

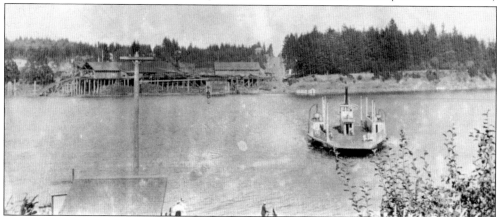

Four

THE SWEDISH
CONGREGATIONS

In 1879, there were about 300 Swedes living in the Portland area and additional Swedes living along Oregon's coastal areas. Rev. Peter Carlson was sent by the Augustana Synod (Swedish Lutheran) to survey the religious needs of the Swedish settlers. His first sermon was delivered on September 14, 1879, one day after his arrival in Portland, to a small group of Swedes on Portland's west side. Reverend Carlson made great efforts to contact Swedes and encourage them to participate in various services. It was not always easy when some Swedes emigrated because of the confines of the Swedish state church, and some wished to practice their religious beliefs as Baptists, Methodists, or *Missionsvänner*.

An organizational meeting was held on December 28, 1879, and the following March, the group became known as the Swedish Evangelical Lutheran Immanuel Congregation and became the center for Lutheran missionary work on the Pacific coast. Property was purchased on Burnside Street between Tenth and Eleventh Avenues. The First Immaneul Lutheran Church building was completed in 1882, with Reverend Carlson's carpenter skills helping in the progress of its construction, and the first service was held on the first Sunday during Advent. Carlson continued his missionary work elsewhere in the Pacific Northwest, and Rev. John W. Skans succeeded him as First Immanuel's pastor. To meet the needs of the Swedes on Portland's east side, under the auspices of the Augustana Synod, a chapel was built and became the setting for the organization of Augustana Lutheran Church in 1906. When Carl J. Renhard arrived in December 1904 and became First Immanuel's pastor after the death of Reverend Skans, the congregation had over 200 members. The original church property was sold in 1905, and new property was acquired at NW Nineteenth Avenue and Irving Street, where the church is presently located.

The next Swedish church to be founded in Oregon was the First Lutheran Church of Astoria, and Reverend Carlson was responsible for its organization on March 23, 1880. The organizing of Swedish congregations followed a similar pattern regardless of the denomination: missionaries were sent out to determine the needs of locals, meet with those who were interested, and help them establish churches.

The first structure for First Immanuel Lutheran Church congregation was built in 1882 on Burnside Street between Tenth and Eleventh Avenues on the west side of Portland. The carpentry skills of Rev. Peter Carlson, a missionary from the Augustana Synod, were an asset during the completion of the church building. (Courtesy of Oregon Historical Society.)

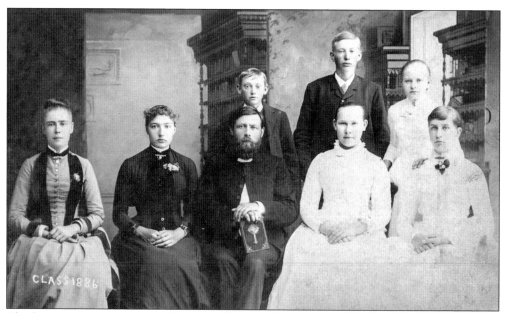

The first group to complete confirmation classes at First Immanuel included these young people pictured in 1886. Their pastor was Rev. John W. Skans, seated in the center. During the time Reverend Skans served the congregation of First Immanuel, a chapel was built on Portland's east side, and another Lutheran congregation was formed in Powell Valley, Sharon, in 1899. (Courtesy of Oregon Historical Society.)

First Immanuel was built in 1905 at NW Nineteenth Avenue and Irving Street in Portland. A succession of Swedish pastors served the church until 1973, when the first non-Swedish pastor assumed duties there. A *Julotta* (early morning Christmas service) continues to be held annually for Swedish American families and anyone who wishes to partake in a legacy of tradition and culture. (Courtesy of Oregon Historical Society.)

This souvenir composite photograph was made for First Immanuel's harvest festival that was held on October 10, 11, and 12 in 1912. The photograph shows the church, the pastor's residence next to the church, and the pastor at that time, J. Richard Olson. The photographer, John Erickson, was just beginning his long career spent capturing events in Portland's Swedish community. (Courtesy of Ross Fogelquist.)

Den första sv. luth. Kyrkan på stilla hafskusten.
— Byggd år 1880 —

3477 M.D.K

The next Swedish church founded in Oregon was the First Lutheran Church of Astoria, which was organized by Rev. Peter Carlson on March 23, 1880. A small church was built and then dedicated on April 1, 1883. After several different buildings and mergers, the congregation became known as Peace Lutheran Church in 1974 and now has its home in a building designed by John Wicks and his daughter Ebba Wicks Brown. (Courtesy of Oregon Historical Society.)

Oregon Journal THURSDAY, MAY

y's wind, unusual but
t this season of the
of 48 miles an hour
:25 a. m. Strong
ately 30 miles
today. The
rned

NOTICE
All persons interested in organizing a Swedish Lutheran Church on the East Side will please meet at the chapel, corner Rodney Avenue and Stanton Street, next Thursday, May 24, at 8 p.m.—Committee.

PICTURE FRAMING
224 Morgan bldg.
TBL. cloth, linen, 3½ yds., 192-thread short, lgth. tbl. cloths; napkins. F

Little did Augustana's founders realize during their first meeting, May 24, 1906, that the classified advertisement in the *Oregon Journal* the week before spearheaded an eventual congregation of 621 members 40 years later. To Mrs. O. W. Axelson and Mr. J. P. Wistrand vast credit for bringing Augustana into existence should be given.

A meeting was announced in the *Oregon Journal* for those interested in organizing a Swedish Lutheran church on Portland's east side. The meeting took place on Thursday, May 24, 1906, at the east side chapel built during Rev. John W. Skans's tenure at First Immanuel. This was the beginning of the Augustana congregation. (Courtesy of Ross Fogelquist.)

C.G. Bloomquist served the Augustana congregation from 1923 until 1928. This photograph features the confirmation class of 1924; from left to right are (first row) Eyvar Carlson, Agda Peterson, Pastor Bloomquist, Hulda Ekstrom, and Agnes Olsen; (second row) Gilbert George Erlandson, K. Howard Peterson, Lloyd T. Haggbloom, J. Ness, Julius Olsen, Oscar Richard Olson, and Stanley Nelson. Agnes later married Henry Ericksen, and they owned the Ericksen's Boulevard restaurant, featuring Scandinavian menu items, on SW Barbur Boulevard for many years. (Courtesy of Ross Fogelquist.)

Augustana Lutheran Church's 39-foot steeple, with its 8-foot cross, was lifted into place in early April 1950. Construction of the new brick church cost $160,000 (roughly $1,679,000 today) and was built by A.V. Peterson, a general contractor. Lawrence, Tucker, and Wallman were the architects. (Courtesy of Oregonian Publishing Company and Oregon Historical Society.)

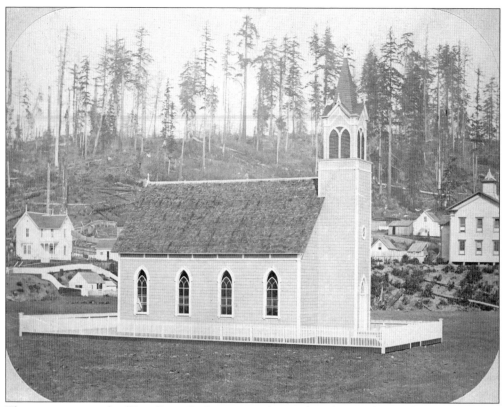

The missionary work of Rev. Peter Carlson was widespread in the Pacific Northwest. Wherever Swedish communities were found, a Lutheran congregation was eventually formed—even in remote areas. The church in Marshfield (Coos Bay) was organized in 1884. Today, the rebuilt church is known as the Gloria Dei Lutheran Church. (Courtesy of Coos Historical Museum, CHM 998.2.16.)

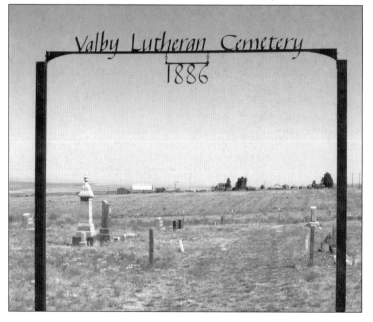

A number of Swedish families came from settlements in the Midwest and elsewhere to Eightmile and Gooseberry and other areas around Ione in Morrow County. They were attracted by the Homestead Act, which permitted them to acquire land for a small sum if certain improvements were made to it. Sheep-herding, and then wheat-farming, sustained the newcomers. (Courtesy of Janet Lundell Ahlin.)

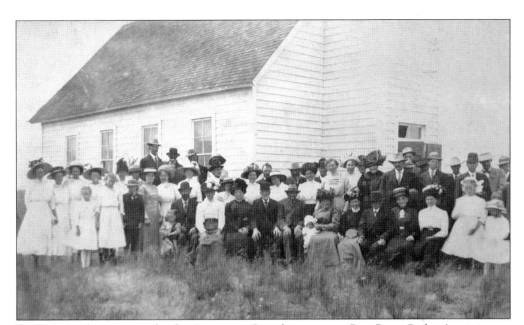

Dr. Erik Norelius was sent by the Augustana Synod to carry on Rev. Peter Carlson's missionary work in Washington and Oregon. On April 19, 1886, Dr. Norelius met with those interested in organizing a congregation at the home of John Johnson. Five acres of land were donated by the Andrew Peterson family and set aside for a church and cemetery. This photograph is from around 1900. (Courtesy of Janet Lundell Ahlin.)

Valby Lutheran Church remains a beacon of faith for those who are inspired by the determination of the Swedish settlers. Janet Lundell Ahlin, one of their descendants, describes the view from the cemetery: "I love that on a clear day you can see Mount Hood, Mount Saint Helens, Mount Rainier, Mount Adams, and Mount Jefferson from there. The wind almost always blows across the rolling hills." (Courtesy of Janet Lundell Ahlin.)

The Swedish Evangelical Lutheran Carlsborg congregation was organized in 1907 with the help of Pastor Carl J. Renhard, and the building of a church for the Carlsborg community of Swedish settlers began soon after. The church was dedicated the same year, and Pastor Renhard also organized a Sunday school. In 1945, the name Carlsborg was changed to Colton. (Courtesy of Ann Baudin Stuller.)

At first, the Swedish Evangelical Lutheran church records were kept in Swedish, but after the congregation voted in 1937, English became the official language of the church. The church banner in this photograph reflects the Swedish heritage of the community by incorporating the Swedish flag in its design. (Courtesy of Ann Baudin Stuller.)

Samuel Magnus Hill (1851–1921) served the Carlsborg congregation during his sabbatical year from Luther College in 1915. Born in Östergötland, Hill immigrated to Nebraska and was a professor at and president of Luther College. He never returned to his position at Luther College but sought ordination and continued as pastor of the Carlsborg church. He was not only an academic but also a poet and pacifist. (Courtesy of Swedish Roots in Oregon.)

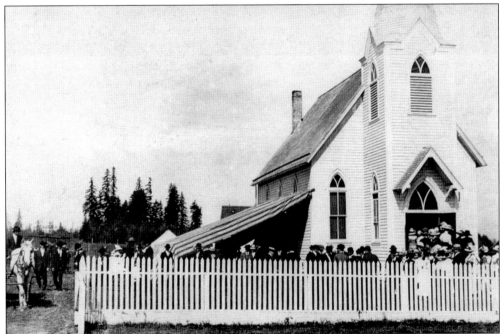

The Swedish Evangelical Lutheran Bethany congregation was organized in the farming community of Warren in Columbia County in 1907. In 1908, C.J. Larson donated an acre of land on Church Road, and the congregation purchased an additional two adjacent acres for a cemetery. Bethany Lutheran Church was built in 1908 in 100 days using volunteer labor and at a minimal cost. (Courtesy of Ross Fogelquist.)

The altar painting in Bethany Lutheran Church is by the artist Olof Grafström (1855–1933) from Attmar, Medelpad, in northern Sweden. A member of the Bethany congregation commissioned the painting for the church. Grafström was responsible for about 200 altar paintings in Lutheran churches throughout the United States. (Courtesy of Rhonda Erlandson.)

The beginning of the First Covenant Church (*Missionsvänner*) in Portland can be traced back to 1887, when a church missionary settled there. Rev. Adolph Lydell had been originally sent to Alaska and returned via Portland. The Mission Covenant Church in Portland was organized in October of that year, and the following year, the first pastor, J. Almer, was called. (Courtesy of Ross Fogelquist.)

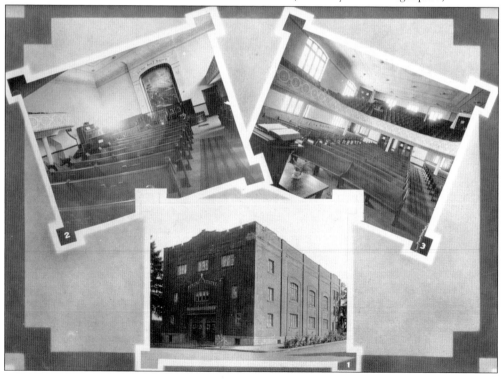

In 1891, property was acquired at NW Seventeenth Avenue and Glisan Street, and the First Covenant Church was built. Pastor Benedictus J. Thorén (Bengt Johan Johansson; 1867–1943), born in Småland, served the congregation from 1907 until the 1920s. In 1911, the original building was razed, and a new structure took its place, which still stands today. The First Covenant Church moved to Portland's east side in 1955. (Courtesy of Oregonian Publishing Company and Oregon Historical Society.)

Mission Covenant churches were also organized in Powell Valley and Damascus, east of the Portland metropolitan area. On March 2, 1947, Hillsview Mission Covenant Church celebrated a newly enlarged building with a service of rededication. On April 19, 1964, the church celebrated its 50th anniversary. (Courtesy of Ross Fogelquist.)

On January 1, 1884, the First Scandinavian Baptist Church was organized with the help of Rev. Gustaf Lilljeroth. The church moved to several locations on Portland's west side. With Portland's growth on the east side, the church acquired property at NE Seventh Avenue and Clackamas Street. The new Swedish Baptist Temple was completed in 1927. In 1942, the name was changed to Temple Baptist Church. (Courtesy of Ross Fogelquist.)

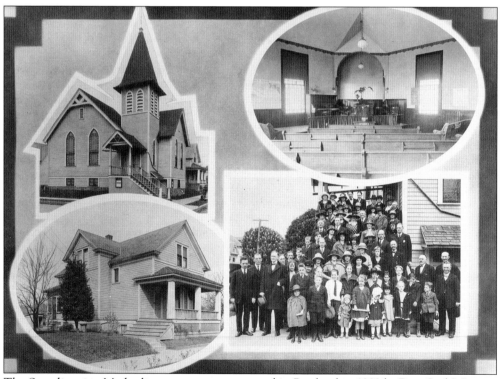

The Scandinavian Methodist movement was started in Portland in 1882 by Rev. Carl J. Larsen and eventually split into separate congregations according to language. The Swedish Methodist Episcopal Church was organized in 1890, and the church was built in 1900 on Mississippi Avenue in north Portland. Various Scandinavian and German Methodist Episcopal churches eventually merged with the Oregon Annual Conference (Methodist) in the early 1920s and 1930s. (Courtesy of Ross Fogelquist.)

Five

PARTICIPATION IN PUBLIC LIFE AND SERVICE

Once the Swedes were established in the community, many of them gained leadership roles—first in their churches and then in various social organizations, where they developed health benefits for their members. Arising from the desire to serve others in need, a hospital society was formed by members of First Immanuel Lutheran Church, and an option on property at Stanton Street and Commercial Avenue was taken for the establishment of Emanuel Hospital in 1909.

Rev. Carl J. Renhard was the originator of the property option and served as one of the founding board members of the new hospital. Other members present at the first organizational meeting on September 14, 1909, included Rev. J.E. Nordling, Anton Hendrikson, Swen Peterson, A.J. Staffanson, Sam Holm, John W. Hawkins, A.L. Moreland, and Frank O. Carlson. Reverend Renhard later served as its first official superintendent until 1915, having resigned as pastor of First Immanuel in 1910. Deaconess Betty Hanson was chosen as superintendent of nurses and remained at Emanuel until 1926. Today, Emanuel Hospital is one of the largest medical centers of Swedish origin in the United States.

As the involvement widened and extended into the local community, Swedish immigrants and first-generation Swedish Americans occupied governmental, political, and educational positions from the local classroom to the office of governor of Oregon. Nearly 20 people of Swedish origin served in the Oregon Legislature from 1911 to 1947: John A. Westerlund, Carl A. Appelgren, C.J. Forsstrom, David E. Lofgren, Conrad P. Olson, Herman H. Chindgren, Albert T. Peterson, Gust Anderson, Mark J. Johnson, Gustav A. Hellberg and his son Fred A. Hellberg, O. Henry Oleen, Carl Engdahl, Art W. Lindberg, Henry E. Peterson, Oscar H. Bengtson, Albin Walter Norblad, and Albin Walter Norblad Jr., who also was a member of the US House of Representatives. Among these men were attorneys, farmers, labor leaders, and pharmacists who represented areas from Astoria to the wheat fields of eastern Oregon.

The original home of Emanuel Hospital was in a rented ornate frame building on SW Tenth Avenue and Taylor Street in Portland. The hospital began operation on January 23, 1912, with 25 beds. The nurses lived on the third floor and carried patients up and down the stairs when necessary. (Courtesy of Ann Baudin Stuller.)

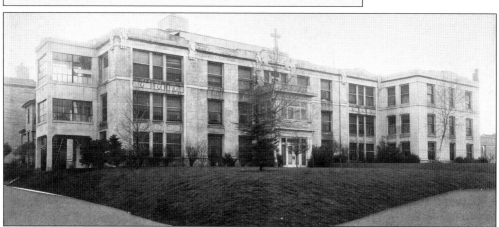

The plan to build a hospital on property at NE Stanton Street and Commercial Avenue became a reality in 1914 with the construction of a three-story, 60-bed concrete structure. The hospital formally opened a year later. (Courtesy of Oregon Historical Society.)

Deaconess Sr. Betty Hanson (1876–1962), born in Farhult, Skåne, was the superintendent when it came to the operation of the hospital. As superintendent of nurses, Sister Betty provided the necessary assistance for the third hospital superintendent, Dr. A.M. Green, a clergyman by training, to become more than just an advisor, which had largely been the role of his predecessors. (Courtesy of Sue Brooks Ceglie.)

Sr. Betty Hanson may have somewhat intimidated the nurses, but she reputedly did not raise her voice when talking to her charges. It was said that Sister Betty and a spot of dirt could not coexist in the same room. During the hospital's early years, she was known to personally can fruit during the summer for the hospital's needs during the winter. (Courtesy of Oregon Historical Society.)

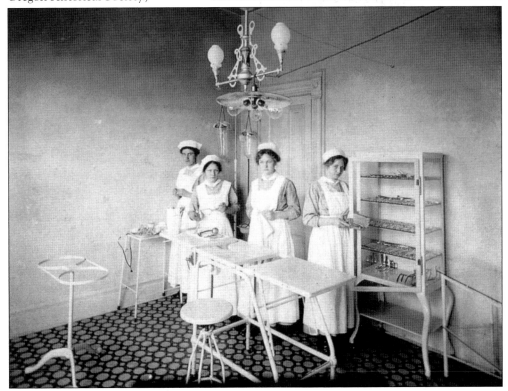

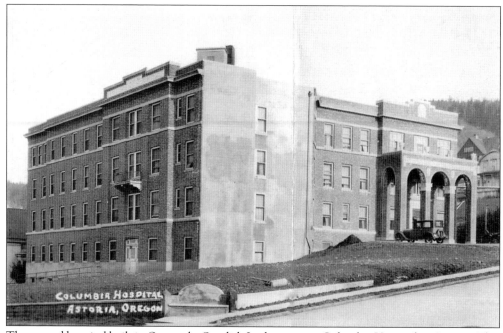

The second hospital built in Oregon by Swedish Lutherans was Columbia Hospital in Astoria. This hospital opened in 1927 at Sixteenth Street and Franklin Avenue. (Courtesy of Ross Fogelquist.)

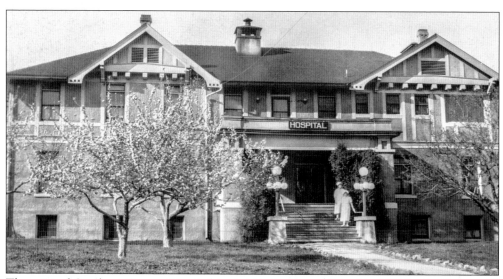

The original Southern Oregon Hospital in Ashland was established in 1907 by Dr. Frances G. Swedenburg (Frans Gustav Hansson), born in Karleby, Skaraborg. A new hospital opened in 1910, and a school for nurses was started in 1912. The location of the hospital in Ashland was on the current site of Southern Oregon University. This photograph is from around 1929. (Courtesy of Oregon Historical Society.)

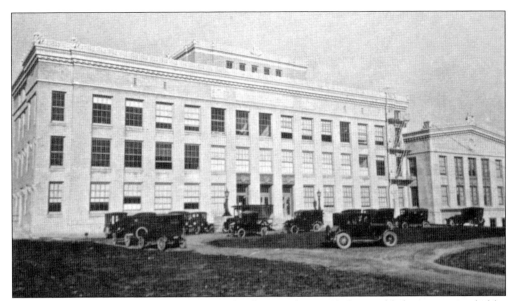

The Multnomah County Hospital in Portland opened in 1923. Its establishment was aided by the chairman of the board of county commissioners, Charles Rudeen (1868–1938), who was from Vislanda, Kronoberg. The hospital contracted with the University of Oregon Medical School to provide services to those who could not afford them. (Courtesy of Ross Fogelquist.)

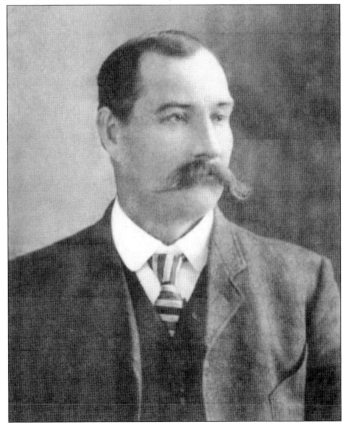

Albert Theodore Peterson (1859–1943), whose father was from Östergötland, was born in Nebraska. He moved to Oregon in 1887, seeking new opportunities, first in Linn County, then settling in Toledo in Lincoln County, all while trying a variety of occupations. In 1893, Peterson began a new industry that involved buying and shipping cascara bark and purchasing property and businesses in and around Toledo. He began serving as a representative in the Oregon State Legislature in 1927. This image is from *Portrait and Biographical Record of Western Oregon*, published in 1904. (Courtesy of the reference collection of the Tigard Public Library.)

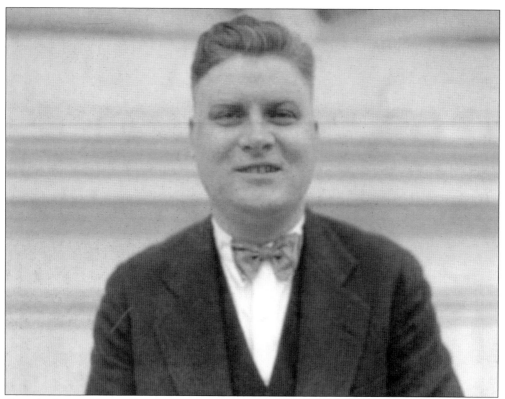

Gust Anderson (August Reinhold Fransson; 1888–1969) was a Portland labor leader from Älvkarleby, Uppsala. He served for 35 years as secretary-treasurer of the Portland Central Labor Council and was a state legislator from 1929 to 1932, 1949 to 1956, and 1959 to 1962. (Courtesy of Oregon Historical Society.)

Albin Walter Norblad (1881–1960) attended the University of Chicago Law School. He was elected to the Oregon state senate and also served as president of the senate. Upon the death of Gov. Issac Patterson on December 21, 1929, he assumed the duties of governor of Oregon, as witnessed by his mother Betty (Bengta) Andersdotter Norblad. Albin Norblad's interests included labor disputes and state acquisition of federal forest land. (Courtesy of Oregonian Publishing Company and Oregon Historical Society.)

96

Albin Walter Norblad's son A. Walter Norblad Jr. (1908–1964) was born in Michigan. He attended the University of Oregon and Harvard Law School and returned to Astoria to join his father's law firm. He served in the Oregon House of Representatives for one term beginning in 1937 and was elected to the US House of Representatives in 1945; he served nine successive terms in Congress until his death in 1964. (Courtesy of Library of Congress.)

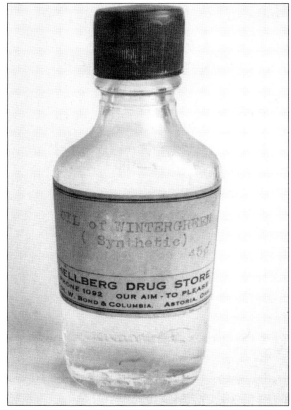

Gustav A. Hellberg (1885–1960) was born in Övertorneå, Norrbotten. He was a pharmacist and had a drugstore in Uniontown, Astoria. He served in Oregon's House of Representatives beginning in 1931. His son Frederick A. Hellberg would hold the same position starting in 1945. (Courtesy of Julia Barbee Suplee.)

John Nyberg, in addition to working as a farmer, played an important role in the Tualatin community. He was mayor of the city of Tualatin for 26 years, as well as a Washington County road supervisor and a Washington County commissioner. His long-standing friend from Silverton, Arthur F. Hobart, is on the right. (Courtesy of Christine Nyberg Tunstall.)

Capt. O.F. Jacobson was a civic booster for Newport. He served as interim mayor, city councilman, and city treasurer, as well as president of the Port of Newport for 16 of the 20 years he was on the board. After Jacobsen's death, a resolution passed by the council read, in part, "The city government has lost one of its most diligent, efficient and congenial members." (Courtesy of Diane L. Glase.)

Emil "Iron Man" Nordeen (Per Emil Nordén) was born in Norsjö, Västerbotten, in 1890 and later settled in the central Oregon city of Bend. He was an active cross-country skier and received "The Klamath" trophy after winning the Fort Klamath to Crater Lake Nordic race for a second time. The solid silver trophy stands 38 inches high. Nordeen won in 1929 and 1931, completing the course in under 6 hours both times. He donated the trophy to the Swedish Ski Association in 1960. (Courtesy of Vanessa Ivey, Deschutes County Historical Society and Museum.)

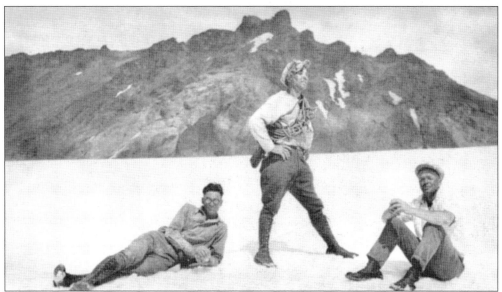

Emil Nordeen, an avid outdoorsman, poses between fellow mountaineers Nils Wulfsberg (left) and Nels Skjersaa around 1927. Credited with a number of difficult ascents in the Cascades, the friends claimed the honor of being the first to climb to the top of Haystack Rock on the Oregon coast near Cannon Beach, planting a US flag at its crest. (Courtesy of Vanessa Ivey, Deschutes County Historical Society and Museum.)

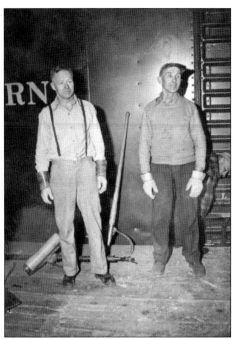

On February 26, 1951, Nels Skjersaa (at left in the image at left) and Emil Nordeen loaded the last pine board shipped from the Shevlin-Hixon plant before it shut down. Emil moved to Bend in 1920 and went to work for the Shevlin-Hixon Lumber Company. There, he met his lifelong friend Nels Skjersaa, and for 31 years, the two men worked as a team loading finished timber into railroad boxcars. Pictured below around 1928, the "Musketeers of the Mountains"—Nels Skjersaa (left), Nils Wulfsberg (center), Emil Nordeen, and Chris Kostol (not pictured)— were the founding members of the Skyliners, an organization that promoted outdoor recreation and search-and-rescue preparedness. In September 1927, the four Scandinavians led a heroic hunt for two lost climbers near North Sisters. The search, although unsuccessful, led to the formation of the Skyliners two months later. The organization grew to 300 members within its first years. (Both, courtesy of Vanessa Ivey, Deschutes Historical Society and Museum.)

Six

ART, MUSIC, AND PUBLICATIONS

One of the most universally acknowledged contributions made by Swedish immigrants to the arts is in the realm of music and, in particular, singing. Swedes are noted for their love of singing, which they carried with them from deep within their heritage. One hymn from the Lutheran tradition, "O Store Gud" ("How Great Thou Art"), based on a traditional Swedish folk melody and a poem written by Carl Boberg, and one from the Covenant tradition, "Tack o Gud" ("Thanks to God"), have long been a part of Swedish choral repertoires. It seems wherever a number of Swedes settled, they sang. Astoria, Colton, Coos Bay, and Portland actively supported choral groups.

Olof Grafström and Ernst Skarstedt were contemporaries; Grafström was an artist, and Skarstedt was a writer and photographer. On occasion, they would collaborate, and Skarstedt's writings would be illustrated with Grafström's pen-and-ink sketches. Grafström's altar paintings were prized by the churches fortunate enough to have commissioned them. Language and heritage united both men in their professions, as did those who followed them.

A successful newspaper, *Oregon Posten,* organized and run by Fredrik Wilhelm Lönegren in Portland, Oregon, unified the Swedish-speaking population on a weekly basis. Fredrik's wife, Catherine Louise Wedmark Lönegren, served as the associate editor of the newspaper.

Samuel Magnus Hill wrote and published poetry in Swedish. A generation later, Viola "Vi" Maria Håkansson Gale wrote poetry, but by that time, it was written in English.

The Runquist brothers, Albert and Arthur, were first-generation Swedish Americans and, as artists, captured the Oregon coast and its vibrant natural beauty in a nontraditional way. They also portrayed the lives of people working there.

Emil Holt loved Swedish quartet songs, which were performed on an informal basis by volunteer quartets and choruses in the Portland area. In 1903, Holt organized the Swedish Singing Club Columbia with a few male singers, and gradually, more were attracted to the club, the members of which are pictured here in 1910. (Courtesy of Ross Fogelquist.)

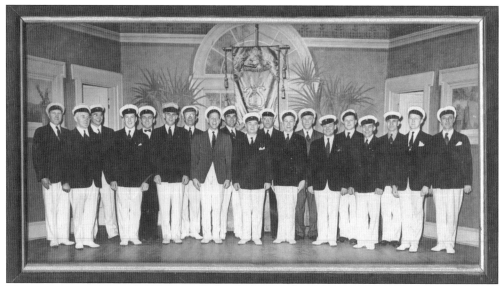

The traditional white singers' caps easily identified Portland's Swedish Male Chorus members when they performed at a Midsummer celebration. As members of the American Union of Swedish Singers (AUSS), they participated in national events as well as performing locally. Today, the AUSS has over 25 member choruses in North America. The photograph is from the 1950s. (Courtesy of Ross Fogelquist.)

Edwin Okerstrom (Åkerström) was born in Fjällsjö, Västernorrland, in 1895. He began directing the Swedish Male Chorus in 1925 and was also active in folk dance groups helping to preserve traditional Swedish dances. Professionally, he was a tailor, which helped in assuring that the choir was always neatly dressed during performances. He married Julia Alvilda Johnson in 1942, and she was also active in the Swedish singing community. (Courtesy of Ross Fogelquist.)

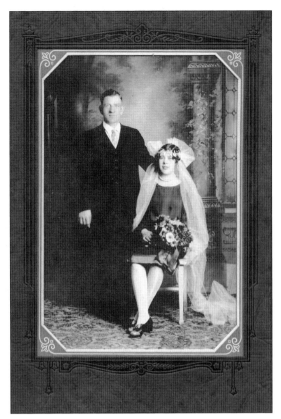

Oscar Näström (1898–1987) was born in Gudmundrå, Västernorrland, and immigrated in 1923. He came from a family who all played musical instruments or sang. After settling in Portland in 1943, he joined the Swedish Male Chorus, where he sang tenor for 44 years and played the violin for folk dance groups and Midsummer celebrations. He and his wife, Mary A. Erickson, were both extremely active in Portland's Swedish community. (Courtesy of Ross Fogelquist.)

Swedish immigrants often maintained their love of music, both vocal and instrumental. For those accustomed to the social setting of Saturday night dances, live music played an important recreational role, especially in the summer. The John Nyberg family of Tualatin even had their own family orchestra. (Courtesy of Christine Nyberg Tunstall.)

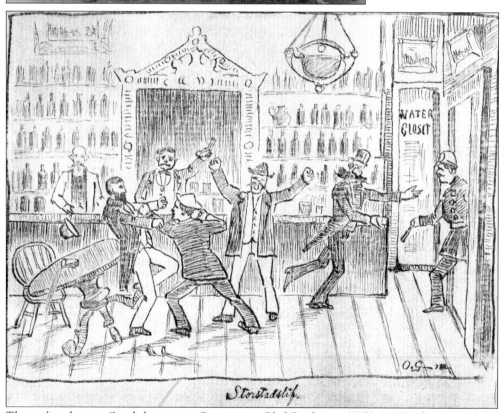

The earliest known Swedish artist in Oregon was Olof Grafström (1855–1933), who painted the altar painting in Bethany Lutheran Church in Warren. He also recorded his stay in the Pacific Northwest with pen-and-ink sketches and illustrated *Vid hennes sida*, a book written by his friend Ernst Skarstedt. This sketch appears to be a tongue-in-cheek interpretation of life in the big city of Portland. (Courtesy of Ross Fogelquist.)

Olof Grafström was from Medelpad and graduated from the Academy of Fine Arts in Stockholm in 1882. He was a contemporary of the well-known Swedish artists Anders Zorn and Bruno Liljefors and was primarily a landscape painter. Portland was Grafström's destination when he immigrated to the United States in 1886. (Courtesy of Ross Fogelquist.)

From Portland, Grafström went to Spokane and then to Bethany College in Lindsborg, Kansas. In 1897, he became a professor of art at Augustana College in Rock Island, Illinois, where he taught until 1926. Two years later, he returned to Sweden to settle permanently. In one of his pen-and-ink sketches, Grafström included this self-portrait, revealing his observational skills and sense of humor. (Courtesy of Ross Fogelquist.)

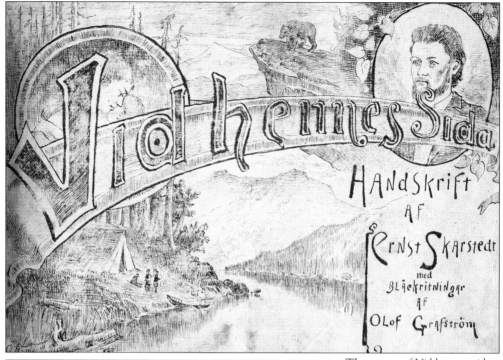

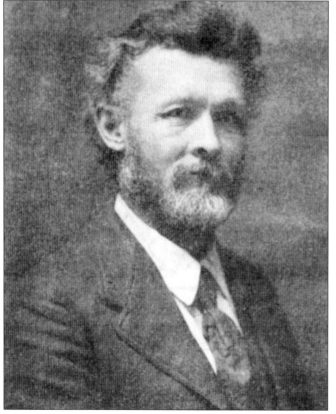

The cover of *Vid hennes sida* shows more of Grafström's sketches, including a small portrait of the author, Ernst Skarstedt. The text is in Skarstedt's handwriting, and the book is a biography written as a tribute to his first wife after her death. The was the first book printed in Swedish in Oregon. (Courtesy of Ross Fogelquist.)

Ernst Skarstedt (1857–1929) was born in Bohuslän. He was a writer, journalist, and amateur photographer. He immigrated to the United States in 1878 and spent most of the following years on the West Coast. Skarstedt's trilogy about the states of Washington and Oregon is considered to be among the best-known resources about Swedes who settled in the Pacific Northwest. (Courtesy of Ross Fogelquist.)

After others had made several attempts to publish a Swedish language newspaper in Portland, Fredrik W. Lönegren (1860–1937) began to edit and issue the weekly *Oregon Posten* in 1908. Lönegren first settled in Minneapolis, Minnesota, having emigrated from Kronoberg in 1889, and married the daughter of Per and Christina Wedmark from Gävleborg, Catherine "Carrie" Louise. The paper continued until 1936, when it merged with a Seattle-area paper and became *Svenska Posten*. (Courtesy of Ross Fogelquist.)

Arthur (1889–1971) and Albert C. (1894–1971) Runquist were the sons of Johannes and Henrika Rönnqvist from Gammelgården, Norrbotten. Arthur and Albert were born in Grays Harbor County, Washington; however, the family later moved to Portland. (Courtesy of Ann Baudin Stuller.)

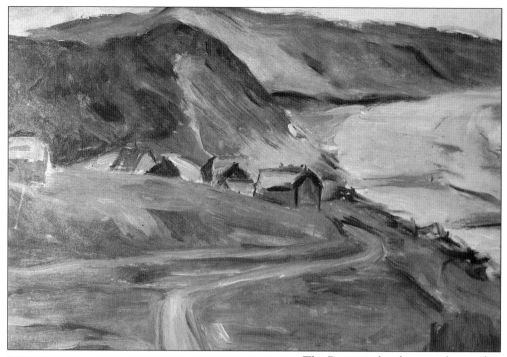

The Runquist brothers, Arthur and Albert, spent many years painting Oregon coastal landscapes—and the people who lived among them—during the time they spent at Neahkahnie in Tillamook County. The brothers' art depicted fishermen, laborers, domestic scenes, and simple landscapes. Sometimes, their paintings reflected a more abstract view of the natural world. It has been said they even contributed to one another's paintings. Their works were often unsigned or simply signed "A. Runquist" regardless of whether the painting had been created by Arthur or Albert. Occasionally, there are paintings on both sides of the paper or canvas. The Runquist brothers actively painted until shortly before their deaths, which were only months apart. (Both, courtesy of Ann Baudin Stuller.)

Seven

HERSTORY

A number of young Swedish female immigrants found their first employment as maids and domestics working in private homes. They were often from rural communities and accustomed to hard work. As live-in servants, they had the opportunity to learn English and experience American customs and practices firsthand. Some would save their earnings to purchase fashionable clothing and hats and then be photographed in their finery. They sent these photographs to Sweden to show what a "good life" was available in the United States. Eventually, most of these young women married and disappeared from the employment scene. Anna Björkman (Birchman) Mills was one of the young Swedes who arrived in Portland with employment waiting for her. Her moving diary has been preserved and is available in translation through the Oregon Historical Society.

Other young women with professional training who immigrated became established as physical therapists, masseuses, and music instructors, as evidenced by announcements in *Oregon Posten*. With the development of hospitals, such as Emanuel in Portland, came the need for nurses. Teaching was another occupation open to women, and a number of immigrants and first-generation Swedish Americans occupied Oregon classrooms.

Equipped with business skills and ambition, some women opened restaurants and featured foods that were familiar to their customers. Others seized their own opportunities, whether that involved establishing a small publishing company, managing a newspaper, designing dresses, or selling antiques.

Ida Johansson Ström (left; 1891–1966) and Hilda Nilsson Swan (1887–1980) emigrated together from Nederkalix, Norrbotten, to Portland in 1911. Both worked as domestics until they married fellow Swedes and had families. They continued their lifelong friendship and shared much laughter regaling friends and family with tales of the past, coffee cups in hand. (Courtesy of Ann Baudin Stuller.)

Anna Björkman (Birchman) Mills (1871–1909) was born in Dalarna and made her first trip across the Atlantic in 1890. Perhaps Anna was cautious with her earnings, as she appeared in this Portland photograph without a fancy hat. She was able to return to Sweden in 1899 for a visit prior to her marriage to Fred T. Mills in 1900. (Courtesy of Alf-Erik Thelin and Elerina Aldemar.)

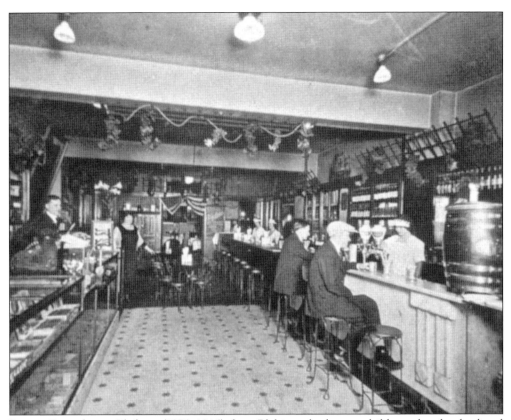

Bengta Svensdotter Olofsson (1876–1946), from Blekinge, had seven children when her husband died in 1910. Unable to cope with her family, she immigrated to Portland in 1911. She remarried in 1915 and, as Betty Johnson, opened Betty's Lunch in the Multnomah Hotel. Two daughters later joined her. One son, Harry Martinson, became a well-known writer and shared the Nobel Prize in literature in 1974. (Courtesy of Ross Fogelquist.)

Mary (Maria) A. Erickson Näström (1905–1987) was born in Wisconsin to Erik Gustaf and Anna Sofia Eriksson from Järna, Dalarna. The family later settled in Clatskanie, Oregon. Mary was a primary teacher and ended her teaching career at Cedar Hills School in Beaverton, Oregon. Mary, and her husband, Oscar, were participants in numerous Swedish activities in Portland, for which she was awarded the Royal Order of Vasa in 1965. (Courtesy of Ross Fogelquist.)

Emma Eleonora Nordgren (1901–1998) was a professional photographer. She began her career as an apprentice in a photo lab and eventually specialized in passport photography in the 1930s. She was born in Umeå, Västerbotten, and immigrated with her parents in 1910. (Courtesy of Oregonian Publishing Company and Ross Fogelquist.)

One of Emma Eleonora Nordgren's photograph collections included this picture of a Portland photography shop owned by David DeMonbrun. It is likely she either worked there or purchased her photography supplies at this shop. DeMonbrun took several portraits of Nordgren. (Courtesy of Ross Fogelquist.)

Emma Eleonora Nordgren was an active member of the Trails Club of Oregon and led hikes and visits to places of interest. One of her albums contains images from the Columbia Gorge. This photograph, most likely taken on one of the club's outings, features Oneonta Gorge. (Courtesy of Ross Fogelquist.)

The Erland and Maria Håkansson family, from Dalarna, immigrated in 1923 and settled in Clatskanie, Oregon. Standing between Maria and Erland is Viola Maria (1917–2007), who would grow up to become Vi Gale, notable Oregon poet, author, and manager of Prescott Street Press in Portland. (Courtesy of Ross Fogelquist.)

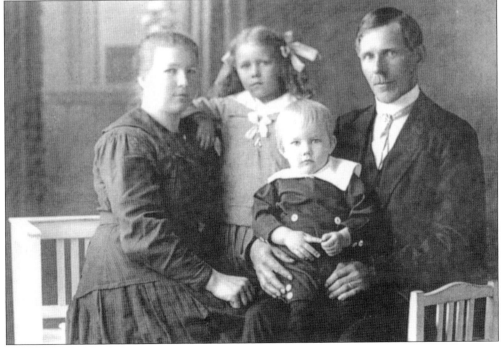

Among the enterprising women in Portland were May E. (1861–1928) and Anne H. (1868–1934) Shogren, daughters of Swedish immigrants Hans and Sofia Shogren (Sjögren). The Shogren sisters (Anne is on the left) had a haute couture dressmaking shop at SW Tenth Avenue and Yamhill Street from the mid-1890s until around 1920. As many as 100 highly skilled seamstresses were employed by the Shogren sisters during the shop's peak years between 1900 and 1910. Typically priced at $250 (about $5,000 today), dresses with the M & A Shogren label ("the Paris of the West") were worn by fashionable women in Portland and elsewhere on the West Coast. (Both, courtesy of Oregon Historical Society.)

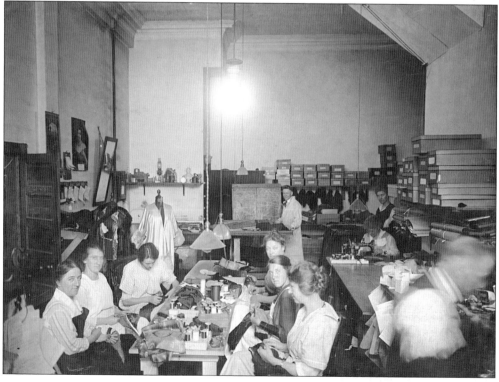

Gladys McKenzie (1888–1986), niece of May and Anne Shogren, is pictured wearing the wedding dress they designed and made for her. She married George Willard Hug around 1910. (Courtesy of Oregon Historical Society.)

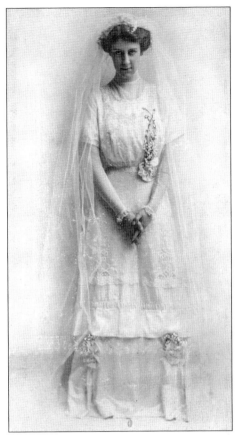

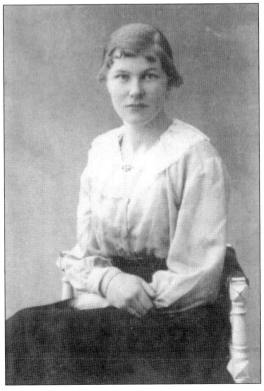

Ruth Erlandson Ellison (1902–1987) was born near Lycksele, Västerbotten, and immigrated to the United States in 1922. She began selling cookware to other women in the logging camp where she was living. From there, she was able to move to a sizable property in the community of Warren in Columbia County and began selling antiques. Her business skills led to her having one of the most successful antique businesses in the region. (Courtesy of Rhonda Erlandson.)

Ebba Wicks Brown (1914–2006), daughter of architect John Wicks and Maria Cederberg, both from the Swedish-speaking part of Finland, became a architect in Astoria. Ebba became a licensed architect in Oregon in 1942 and was the second woman to do so. In 1960, she achieved an additional distinction by becoming the first woman appointed to the Oregon State Board of Architect Examiners. Brown had a substantial hand in designing public and residential buildings in Astoria that reflected modern, international, and Northwest regional styles, including the Astoria Library and the Columbia River Maritime Museum. Together with her father, she designed the First Church of Christ, Scientist, in Astoria in 1951. The building is known for its modern lines and use of natural light in the interior. (Left, courtesy of the *Astorian*; below, courtesy of Ann Baudin Stuller.)

Eight

CELEBRATIONS AND TRADITIONS

Language, cultural heritage, and traditions united the Swedish immigrants in Oregon, no matter where they settled in the state. Of course, there were minor regional differences depending on the area where they were born in Sweden, such as a few food specialties and regional dialects. However, the Swedes all arrived with a basic compulsory education and, for the men, a history of military service. In addition to the holidays of Easter and Christmas are Midsummer (the third Saturday in June) and Lucia (December 13). The celebration of Christmas begins with the first Sunday in Advent, and Christmas Eve is when *tomte* brings *julklappar* (Christmas presents).

It is said that Swedish food is prepared with butter and love, and in keeping with the holidays, it is present in abundance: *sill* (pickled herring), *gravad lax* (salmon cured with salt and sugar), cheeses, pickled beets, herring salad, potatoes, *köttbullar* (meatballs), sausages, ham, and rye bread are basic at a traditional festive meal. Mid-morning and afternoon coffee are often served with cardamom bread, butter cookies, or a cinnamon roll.

Handcrafts were also a part of the heritage the immigrants brought with them. For men, the Old World skills of woodworking, carving, and basketmaking were useful in their new homeland. For the women, the ability to weave, sew, or knit—and to teach those skills to others—helped the traditions to continue.

With the rise of interest in genealogy, present generations have easier access to trace the roots of their heritage and see how it has been preserved in Oregon through various organizations and activities, whether it be in the form of an exhibit, a published book, or the smiling faces of young people at Trollbacken, Oregon's Swedish-language summer camp.

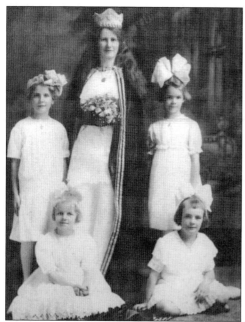

Midsummer, the third Saturday in June, is celebrated outdoors with the raising of a pole decorated with flowers and birch leaves, traditional folk dances, and food specialties. The festivities are celebrated with families and friends. In the past, each Swedish organization in Portland selected a representative, and these representatives would participate in a Midsummer queen contest. Alma Foleen, the 1916 queen, is pictured here with four attendants. (Courtesy of Ross Fogelquist.)

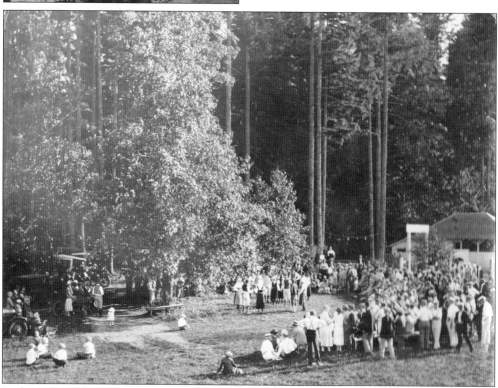

In the early 1920s, Viking Park on the Sandy River east of Portland was the setting for traditional Midsummer celebrations. Since then, different parks have served as venues in the Portland area: Cedarville Park, Gladstone Park, and Oaks Park. Folk dance groups in native costumes perform as part of the program. This is followed by the raising of the decorated maypole, and all ages join in ring dances. (Courtesy of Ross Fogelquist.)

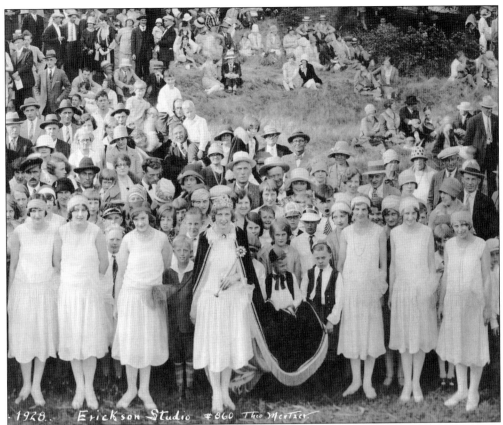

1928. Erickson Studio #860 Theo Mentzer.

Marie Olson was chosen as Midsummer queen on June 24, 1928. John Erickson (1868–1953), from Värmland, was a popular photographer for Swedish events in the Portland area. Erickson took this photograph of Midsummer queen Marie and her court—from left to right in the first row, Vera Swanson, Alfie Nelson, Helga Mattson, Doris Berglund, Astrid Pearson, and Sylvia Anderson—in Gladstone Park in the Portland suburbs. (Courtesy of Tom Swanson.)

The folk dance group in the front performed for a Midsummer program. Their folk costumes represent different regions of Sweden and are traditionally made of handwoven wool (except for the linen shirts and blouses). (Courtesy of Tom Swanson.)

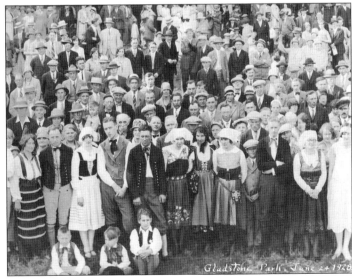

Gladstone Park, June 24 1920

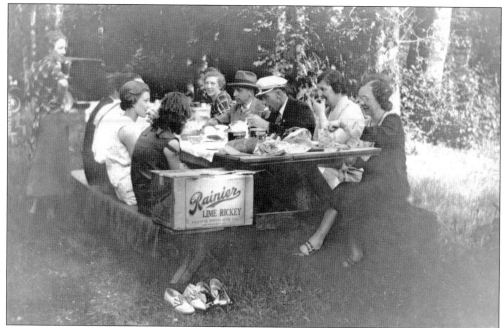

Picnicking at Viking Park was a favorite summer activity. Emma Olson (second from right) enjoyed the company of her daughters Elsa, Viola, and Marie and a group of friends. The Olsons were from Sunne, Värmland. This photograph is from the early 1930s. (Courtesy of Suzanne Lindberg Nelson.)

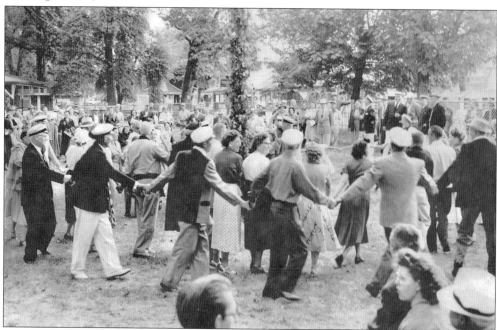

In 1946, Oaks Park in the Sellwood area of Portland was selected for the Midsummer celebration. After the raising of the maypole, the traditional ring dances began, with one and all beckoned to join the circle. The white caps worn by the Swedish Male Chorus indicate that the members were also part of the program. (Courtesy of Ross Fogelquist.)

To retain the heritage of Swedish folk dancing, young people of Nordic heritage are sometimes introduced to its intricate dance patterns and music. Pictured is a group from Coos Bay on the Oregon coast. (Courtesy of the Coos County Museum, CHM 991.N53.2.)

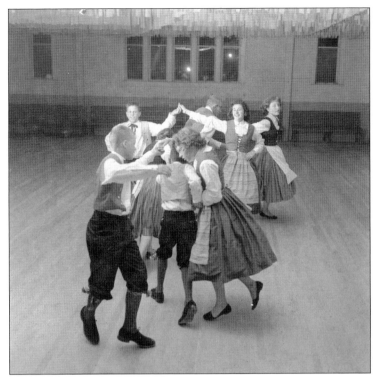

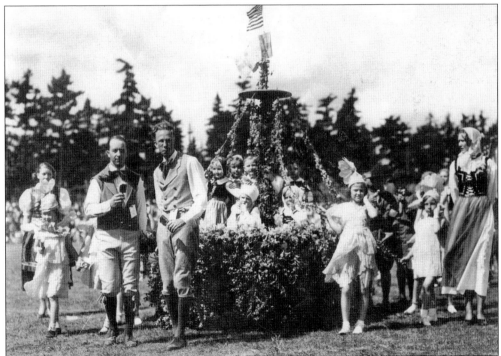

The Vasa Rosebuds provided the opportunity for young children living in Portland to participate in learning about their heritage through music and dance. This is their Swedish Midsummer-themed float entered in the Junior Rose Festival parade in the 1930s. (Courtesy of Ross Fogelquist.)

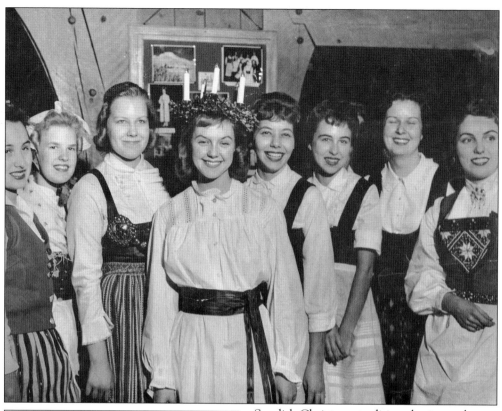

Swedish Christmas traditions begin on the first Sunday of Advent. Often, a lighted star appears in the windows of homes, and candles are everywhere during this darkest part of the year. December 13 is Lucia day, and the occasion is celebrated in both Portland and Astoria. This photograph is from 1956, when Portland's Lucia and her attendants made a visit to Timberline Lodge on Mount Hood. (Courtesy of Ross Fogelquist.)

Lucia Fest

First Presbyterian Church
December 9, 2017 3pm

Sponsored by
New Sweden Cultural Heritage Society
Visit New Sweden at www.newsweden.org
https://www.facebook.com/newswedenportland/

One of the more recently established Swedish organizations in Portland, New Sweden Cultural Heritage Society, sponsors an annual Lucia Fest held in a local church. A program of music and story enhanced by a traditional Lucia procession attracts many. Saffron bread, *pepparkakor,* butter cookies, and a visit from *tomte* are additional features. (Courtesy of Ross Fogelquist.)

Swedish loan words include *smörgåsbord*, which consists of traditional foods often served for special holidays such as Christmas and midsummer. Cheeses, pickled herring, a variety of salads, sausages, small potatoes, ham, and meatballs are typical items. Monica Heise, whose mother was from Värmland, appears ready to begin this Christmas feast in 1953. (Courtesy of Oregon Historical Society.)

Fogelbo, the home of Ross Fogelquist, continues to be a hub for many Swedish activities in the Portland area. It was built for the Oscar Oleson family around 1938 by Henry Steiner, one of the carpenters who worked on the construction of Timberline Lodge. Fogelbo, which features log construction similar to what originated in the Nordic countries, is listed in the National Register of Historic Places. Ross Fogelquist maintains the Portland area's Swedish archives for Swedish Roots in Oregon. (Courtesy of Ross Fogelquist.)

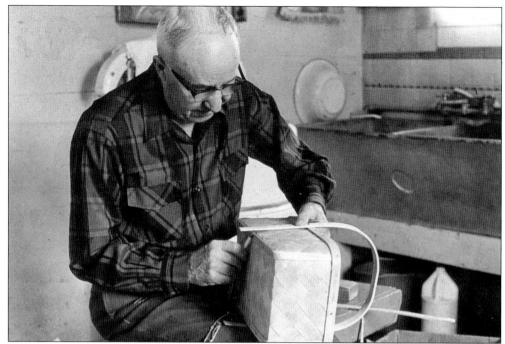

Erick John Peterson was born in 1896 in the village of Våmhus near Mora, Dalarna. When he was 10 years old, his father taught him how to make splints for weaving baskets. When John first came to St. Helens, he worked as a logger. He recaptured his boyhood passion when he started making wastebaskets for the logging camp offices. John found he could market his baskets, and eventually, some were sent to the Smithsonian Institution in Washington, DC, for an exhibit in 1980. His baskets have a variety of sizes and uses, including large backpacks made especially for fishermen. Basketmaking is a traditional Swedish handcraft that is the heart and soul of the creative spirit. (Both, courtesy of Sachiye and John Jones.)

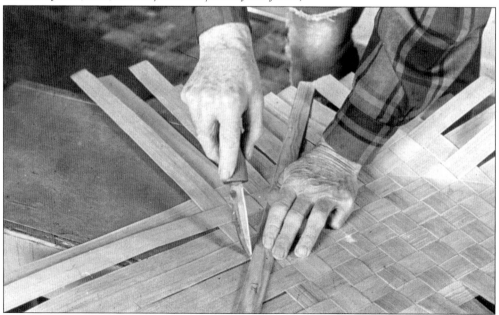

In the spirit of sharing cultural heritage and traditions, Swedish Roots in Oregon presented an exhibit from April to July 2019 at Nordia House, Portland's Nordic cultural center located next to Fogelbo. The exhibit consisted of multiple panels and posters relating the stories of Swedish immigrants and their descendants in Oregon. (Courtesy of Ann Baudin Stuller.)

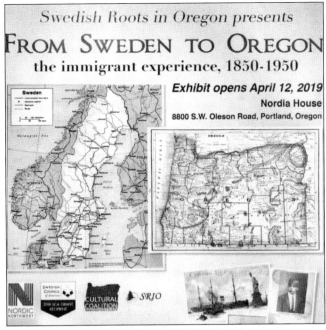

The response to the exhibit was highly positive, and it was accompanied by additional activities such as genealogy workshops and lectures. Sponsors of the exhibit included the Swedish Council of America, the Cultural Coalition of Washington County, Portland-area Swedish organizations, and private individuals. (Courtesy of Ann Baudin Stuller.)

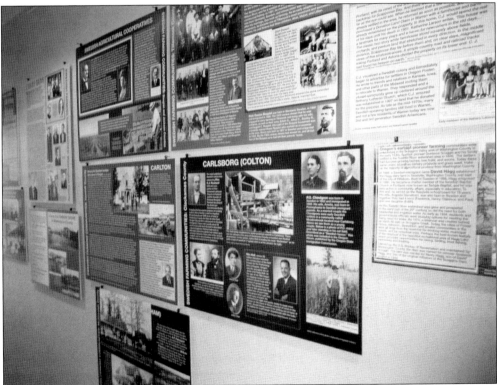

Artifacts were put on display at the 2019 *From Sweden to Oregon* exhibit, including logging boots, books, folk costumes, a trunk and food storage boxes, a chair, long woolen underwear, cooking and baking utensils, a violin, items related to immigrants' daily life, and—of course—an Erick John Peterson basket. (Courtesy of Ann Baudin Stuller.)

The Swedish School in Portland and Trollbacken Swedish language and culture camp offer opportunities for young people to expand their knowledge of and appreciation for their family heritage. Pictured in 2017 are youth leaders at Trollbacken whose faces reveal the pleasure of such experiences. (Courtesy of Ross Fogelquist.)

BIBLIOGRAPHY

Ander, O. Fritiof. *The Cultural Heritage of the Swedish Immigrant: Selected References.* New York: Arno, 1979.

Becket, Florence, and Kathy Carlson. *75 Years of the Valby Lutheran Church.* Ione, OR: Valby Lutheran Church, 1986.

Carlson, William. "The Swedes of Oregon." *American Swedish Historical Museum Yearbook—1946.* Philadelphia: American Swedish Museum, 1946.

Douthit, Nathan. *The Coos Bay Region 1890–1944.* Coos Bay, OR: River West Books, 1981.

First Covenant Church of Portland, 1887–1987: A Time for Reflection, A Time for Renewal. Portland: First Covenant Church, 1987.

Första Svenska Baptistförsamlingen, Minneskrift i ord och bild, 1884–1924. Portland: First Swedish Baptist Congregation, 1924.

Jensen, Doris B. *First Immanuel Lutheran Church: 100 Years: Celebrating Our Past—Facing Our Future.* Portland: First Immanuel Lutheran Church, 1987.

Johnson, John E., ed. *History of Pacific Northwest District Lodge No. 13, Vasa Order of America, 1912–1977.* Seattle: Pacific Northwest District Lodge No. 13, 1977.

Kastrup, Allan. *The Swedish Heritage in America: The Swedish Element in America and American-Swedish Relations in Their Historical Perspective.* St. Paul, MN: Swedish Council of America, 1975.

Nordström, Lars, ed. *Swedish Roots, Oregon Lives: An Oral History Project.* Portland: Swedish Roots in Oregon Press, 2013.

Pearson, John B. *Temple Baptist Church: The First Century, 1884–1984.* Portland: Temple Baptist Church, 1985.

Peterson, Martin. "The Swedes of Yamhill County," *Oregon Historical Quarterly.* Portland: Oregon Historical Society, 1975.

Portrait and Biographical Record of Western Oregon. Chicago: Chapman, 1904.

Skarstedt, Ernst T. *Oregon och Dess Svenska Befolkning.* Seattle: Self-published, 1911.

———. *Oregon och Washington.* Portland: Broström & Skarstedts förlag, 1890.

DISCOVER THOUSANDS OF LOCAL HISTORY BOOKS FEATURING MILLIONS OF VINTAGE IMAGES

Arcadia Publishing, the leading local history publisher in the United States, is committed to making history accessible and meaningful through publishing books that celebrate and preserve the heritage of America's people and places.

Find more books like this at
www.arcadiapublishing.com

Search for your hometown history, your old
stomping grounds, and even your favorite sports team.